IMAGES
of America

SOUTH JERSEY
MOVIE HOUSES

Betty —
I Hope you Enjoy these
S.J. Memories!

10-17-09

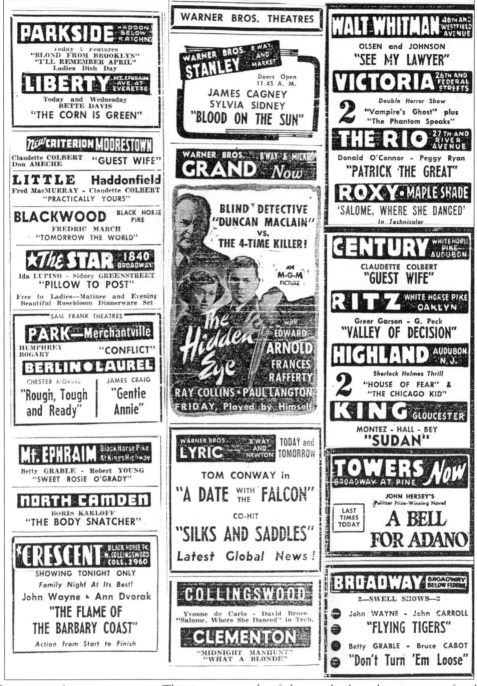

NEWSPAPER ADVERTISEMENTS. This is an example of theater display advertisements for the Camden area in 1945.

On the cover: CRESCENT THEATRE, HADDON TOWNSHIP, 1939. Hunt's Crescent Theatre manager, William Gerst, staged this event as a promotion for the 1939 opening of MGM's *The Women*. (Courtesy Harold Sherwood.)

IMAGES
of America

SOUTH JERSEY
MOVIE HOUSES

Allen F. Hauss

ARCADIA

Published by Arcadia Publishing
Charleston SC, Chicago IL, Portsmouth NH, San Francisco CA

Printed in the United States of America

Library of Congress Catalog Card Number: 2005936619

For all general information contact Arcadia Publishing at:
Telephone 843-853-2070
Fax 843-853-0044
E-mail sales@arcadiapublishing.com
For customer service and orders:
Toll-Free 1-888-313-2665

Visit us on the Internet at www.arcadiapublishing.com

FRANK J. HAUSS. This book is dedicated to my father, Frank J. Hauss, whose lifelong vocation was the profession of theater projection. He taught me the business, instilling in me a love of movies and film technology, and a respect for the art of perfect projection. I miss sharing the booth with him.

CONTENTS

ACKNOWLEDGMENTS

Covering almost 100 years and 200 theaters required the assistance of quite a few people. I am indebted to them and wish to thank them for the personal time offered, along with access to their memories and their collections.

The two largest collections come from Gary Feldman and Paul W. Schopp. The cover photograph is courtesy of Harold Sherwood, former chief projectionist for the Hunt Theatre chain. The Burlington Theatre history and many of the Fox Theatre artifacts are a result of time spent with Stephen Fox. A special thank-you for similar assistance with Camden County goes to Henrietta Kravitz (née Varbalow) and her nephew Michael Varbalow. Noted artist Robert C. Semler, a brother projectionist and avid movie collector, provided many projection room photographs. Peter Childs of the Collingswood Public Library offered time, memories, and access to the files of Collingswood's history.

Others who offered access to a specific town or theater include: Michael F. Stafford and the Sea Isle City Historical Society, Jacob Rosenfeld for the Colonial Theatre, Peggy Corson for the Elmer Theatre, William Frederick Sr. for Swedesboro, Douglas Rausemenberg and the Haddonfield Historical Society for the Little Theatre, James Foreman and James Laymon for the Ocean City Theatre information, and Jane Hamilton (née Foxhill) for the Towers Theatre, Camden. Lou Gaul, entertainment editor for the *Burlington County Times*, provided some original programs and access to the newspaper's photograph archives.

Special thanks also to my friends Joseph Truitt and Joe Baltake for their enthusiasm throughout this project. Last, but always first in my life, is my wife, Maryann. Without her encouragement and help, this work would not have reached completion!

INTRODUCTION

It is Sunday afternoon on April 27, 2003. I am standing on the corner of the White Horse Pike and Kings Highway in Audubon, New Jersey, looking through a chain-link fence as the Century Theatre undergoes demolition. Tearing it down is not easy since it is a complex building with a large auditorium, balcony, and a huge stage and fly loft that towered over the Audubon landscape. I can see pieces of the gold curtain that once majestically framed the screen fluttering in the breeze on the now exposed proscenium. Thoughts of my past and the part the Century played in it race through my mind. Cheering yo-yo contestants on the stage as they tried to win that bicycle, watching Saturday morning cartoon festivals with all the other neighborhood kids, and, later, Friday nights sitting in the area known as the "pit" with the rest of the Audubon High School students, who always sat in the same section of the auditorium: right front after the last "break" aisle. I think about my first salaried job as an usher, and my first boss, Harry Sullivan, manager, and my "break times," often spent in the projection room with Charlie Roop and Johnny Armstrong, the projectionists. They would talk about the "old days" of the business and teach me the "secrets" of the trade. I remember being promoted to doorman, a position that "Eugie" Orowitz (Michael Landon) held at the neighboring Westmont Theatre, and my returning to the Century Theatre to work as a relief projectionist while attending Rutgers University in Camden. Later I would rent the theater for Rutgers to host a live concert featuring the Association, benefiting the university's student union. The Century, now just a pile of rubble, was an important icon in my life, as were many other theaters that once opened their curtains to audiences in South Jersey.

—Allen F. Hauss

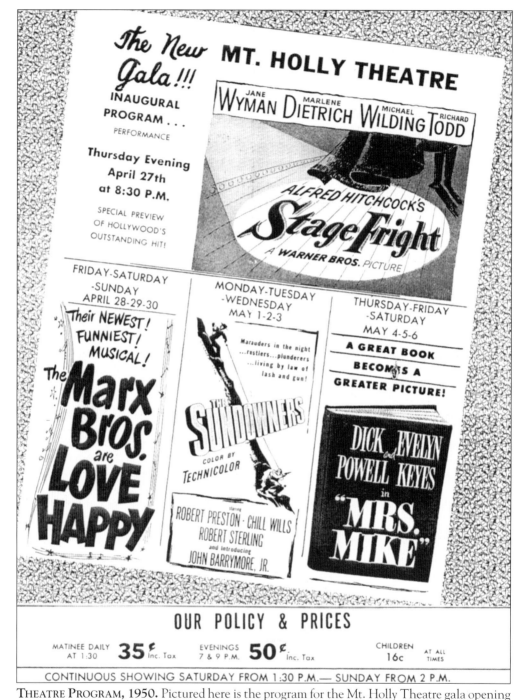

THEATRE PROGRAM, 1950. Pictured here is the program for the Mt. Holly Theatre gala opening on April 27, 1950.

One

CAMDEN COUNTY

Camden County's movie house history began in the early 1900s when Herbert Megowan and Harvey Flitcraft opened the first storefront nickelodeons in the city of Camden. They were soon followed by larger and more elaborate venues, not only in Camden, but in most of the small towns thriving along the rail lines and highways leading out of the city. Real estate developers like Handle and Rovner recognized the value a theater would add to developing towns and, in the 1920s, built large theaters like the Collingswood, the Westmont, the Century, and the Clementon, all featuring vaudeville and film entertainment.

Camden County's most notable motion picture exhibitor was Samuel Varbalow, who started his theater chain in 1925 with the Victoria Theatre in East Camden. He opened his flagship theater, the Savar (named for his mother Sadie Varbalow) in 1938, and he would build Camden's last indoor theater, the Arlo, in 1949. As the industry started to explode, the studios quickly realized that they could make more money by controlling exhibition as well as production. Thus, the major studios began building their own theaters as well as leasing independently owned houses. A landmark Supreme Court decision in 1949 separated exhibition from production, forcing the studios to sell off their theaters and allowing the growth and development of independent chains. The Varbalows would soon own or control over 20 theaters and changed the company name to the Savar Corporation in the 1960s.

The county saw many firsts. The Walt Whitman in Pennsauken had the initial Vitaphone installation outside of Philadelphia, bringing the first "talkies" to South Jersey in 1928. Vitaphone discs were pressed at the Victor Talking Machine Company in Camden. RCA recorded airplane sounds at the Camden Airport for use on the sound track of *Wings*, which won the first Academy Award for Best Picture, and used the Crescent Theatre in West Collingswood as a test site for its "Sound on Film" system. Cinemiracle camera mounts for the production of *Windjammer* were made at Atlas Instrument in Haddonfield. The world's first "Drive-In" theater was on Admiral Wilson Boulevard in Pennsauken.

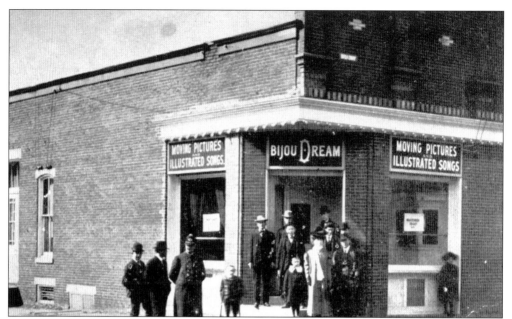

BIJOU DREAM, CAMDEN, 1907. Located at Broadway and Dickenson Streets, the Bijou Dream was typical of the storefront nickelodeons run by Herbert Megowan and Harvey Flitcraft throughout the city. Note the advertising of "Illustrated Songs," the beginning of the "bouncing ball sing-alongs," and perhaps also the start of the karaoke craze. (Courtesy Paul W. Schopp collection.)

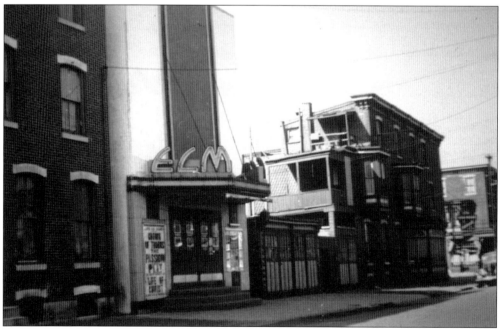

ELM THEATRE, CAMDEN, 1941. Originally opened as a silent movie house, the Elm closed in 1928 without converting to sound. Architect William H. Lee of Philadelphia redesigned the 385-seat house for owner Fred Wieland in 1938. It continued to operate through the late 1950s, when it closed. It was later razed to permit construction of the Northgate Apartments.

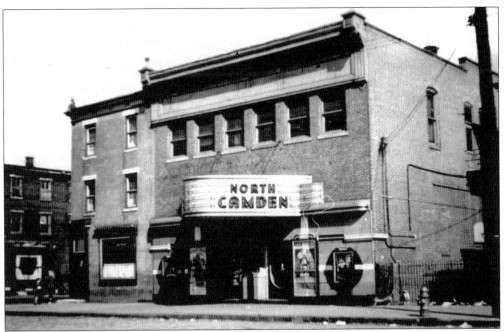

NORTH CAMDEN THEATRE, CAMDEN, 1941. Built in 1921 at Second and Main Streets, this 452-seat theater had a long run as a typical neighborhood house. In the late 1950s, it had a stint as a "live" burlesque house before closing for good. The building is still standing and is in use as a church.

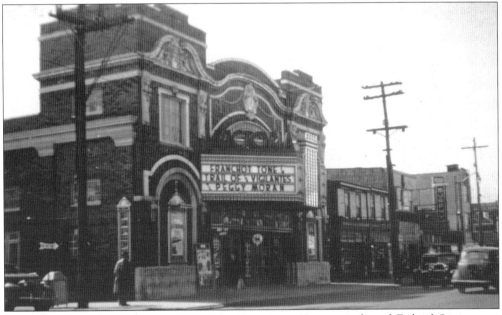

VICTORIA THEATRE, CAMDEN. 1941. The Victoria, at Twenty-sixth and Federal Streets, was the first theater owned and operated by Samuel Varbalow. It had 800 seats on one floor and featured a Wurlitzer pipe organ. The Varbalow chain would eventually include over 20 theaters, mostly in Camden County. The Victoria closed shortly after the company built and opened the more modern Arlo, a block away. (Courtesy Gary Feldman collection.)

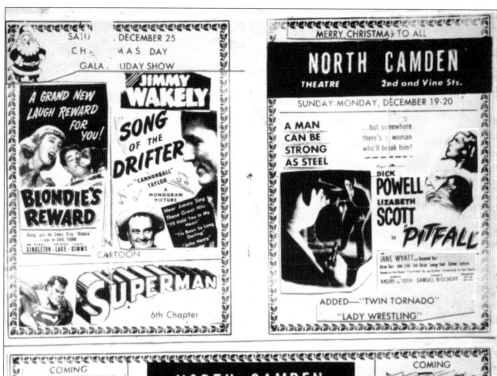

NORTH CAMDEN THEATER PROGRAM, 1949. This is a printer's "paste up" made from various press books of the period. The studios issued press books containing approved copy with graphic advertisements for exhibitors to design their newspaper advertising and weekly programs. Note the mention of short subjects with each attraction, especially the mention of chapter six of *Superman*. Short subjects, especially serials, were always considered an important addition to the program.

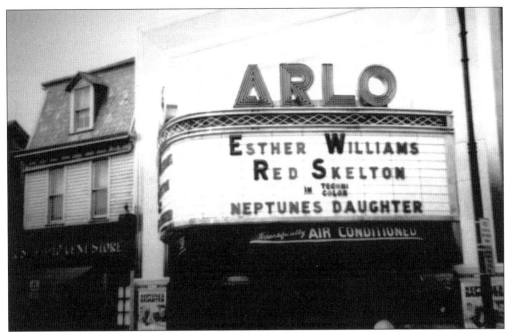

ARLO THEATRE, CAMDEN, 1949. Located at Twenty-seventh and Federal Streets, just one block from the Victoria, the Arlo was the last indoor theater built in Camden. Also a Varbalow theater, it opened on July 7, 1949, with Shirley Temple's *Adventure in Baltimore* and featured the area's only "waterfall" screen curtain. The Arlo was sold to the Milgram chain in 1968, closed in the 1970s, and was destroyed by fire in 2000.

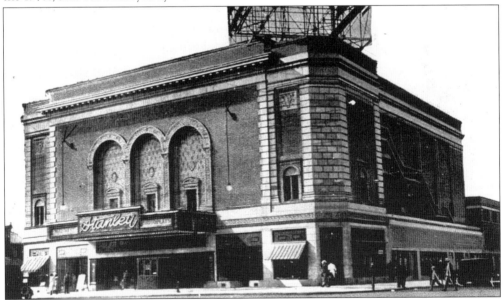

STANLEY THEATRE, CAMDEN, 1926. Located at Broadway and Market Streets, the Stanley opened on February 19, 1926, with *Vanishing American*. Designed by the Hoffman-Henon Company, it had 1,114 orchestra seats, an additional 823 in the balcony, and featured a four-manual Wurlitzer pipe organ. New York City mayor James J. Walker attended the opening to honor his close friend Jules Mastbaum, president of the Stanley Company of America.

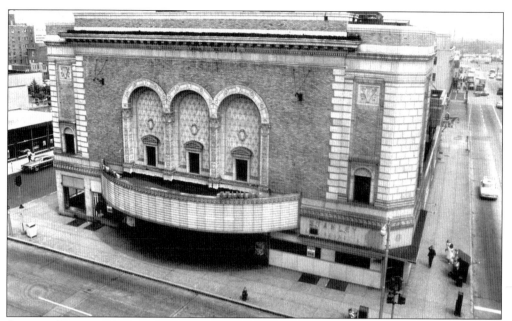

STANLEY THEATRE, CAMDEN, 1966. This photograph, showing the theater's third marquee, was taken just after it closed in 1966. The Stanley was well known for its live stage shows into the 1950s, its first-run film policy, and for the first and only South Jersey installation of the RCA Theatre Television system. This system was used for the closed-circuit showings of championship boxing matches. The theater was razed to permit construction of a hotel that was never built.

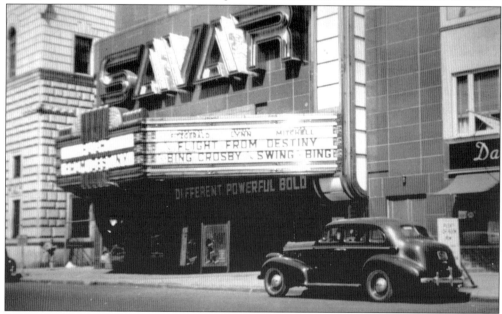

SAVAR THEATRE, CAMDEN, 1941. Market Street, just below Broadway, was the site of the Varbalow chain's flagship theater. It was named for Samuel Varbalow's mother, Sadie Varbalow. The Savar was built in 1938 with 1,200 seats on the orchestra floor, 500 seats in the balcony, and a full stage. Until closing in the 1960s, the Savar and Stanley were Camden's premier first-run houses. It was razed in 1964 to provide parking for the adjacent bank.

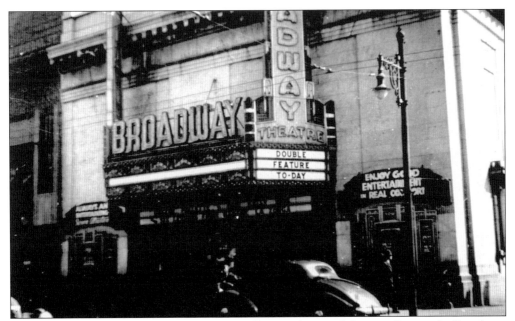

BROADWAY THEATRE, CAMDEN, 1941. Located at Broadway and Carmen Streets, the Broadway, a converted bank building, was opened by the Ellis Theatre chain in November 1933. It had 870 seats on the main floor and 150 seats in the balcony. The opening attraction was *Broken Dreams*. The theater was closed by fire in April 1934. It was redesigned by architect David Supowitz and reopened in August of the same year.

MIDWAY THEATRE, CAMDEN, 1973. The Broadway, at Broadway and Carmen Streets, was purchased by the Varbalow chain in 1951 and renamed the Midway. It usually ran "B picture" double features but was occasionally used to "hold over" Savar Theatre first-run pictures. It was razed in the late 1970s to make way for Camden's new transportation center. (Note the Horn & Hardart restaurant sign to the left of the theater.)

15

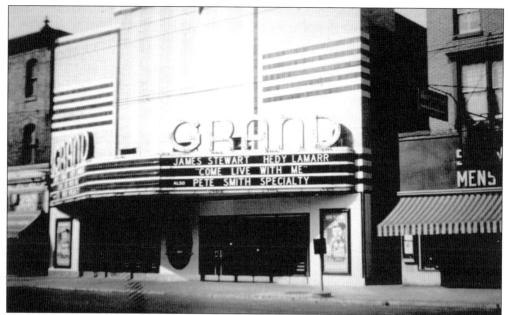

GRAND THEATRE, CAMDEN, 1941. Built in 1915 at Broadway and Mickle Streets, the Grand featured a Pilcher pipe organ and had 671 seats on the main floor and 232 in the balcony. The Stanley Company of America operated it until the Stanley-Warner chain took control and remodeled it in art deco style in 1937. It reopened with *That Certain Woman* starring Bette Davis on October 14 and was sold for retail space in 1951.

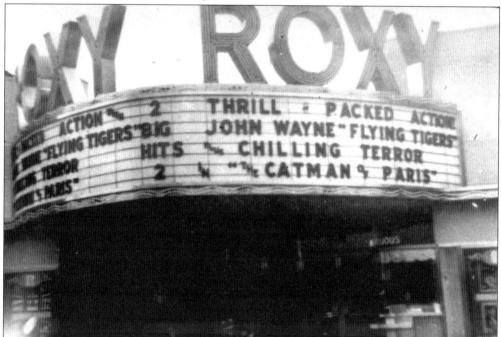

ROXY THEATRE, CAMDEN, 1946. The Roxy was located at 1117 Broadway. It was originally named the Garden when Handle and Rovner opened it in 1922. The building is still standing, complete with marquee, and is in use as a church.

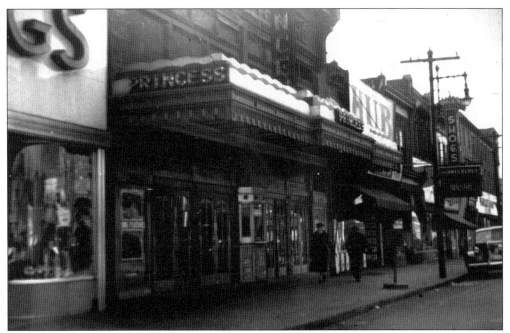

PRINCESS THEATRE, CAMDEN, 1941. Located at Broadway and Chestnut Streets (1104 Broadway), the Princess was managed by the Stanley Company of America from 1918 until the 1930s, when management was assumed by the Stanley-Warner Company. The theater had 574 seats on the orchestra level and 130 in the balcony. In 1919, a Moller pipe organ was installed.

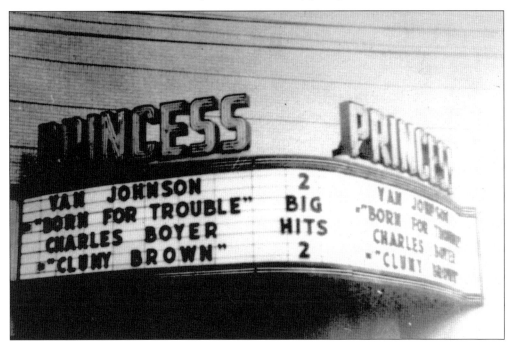

PRINCESS THEATRE, CAMDEN, 1946. This photograph shows the theater with a new modern marquee in 1946. It continued to run into the late 1960s. The building is still standing and has been used as a union hall, a gymnasium, and as several retail stores.

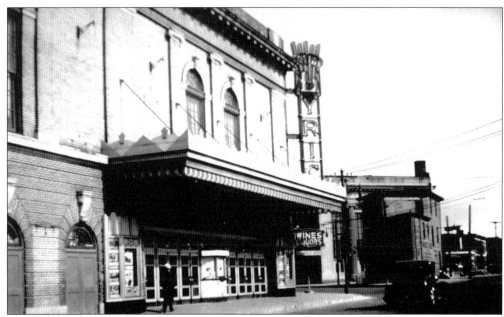

LYRIC THEATRE, CAMDEN, 1941. The Lyric opened at Broadway and Newton Avenue in 1921 with 972 seats on the orchestra floor, 561 in the balcony, and an additional 409 lodge seats. It featured a Moller pipe organ, full stage, and a large orchestra pit. Handle and Rovner assumed management in 1924, followed by the Stanley-Warner Company, and then the Varbalow chain. It closed and was torn down in the late 1950s.

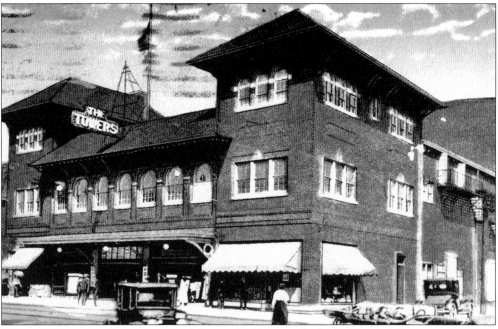

TOWERS THEATRE, CAMDEN, 1922. Newton B. T. Roney built the Towers Theatre in 1912 as a vaudeville house at 704 Broadway (Broadway and Pine Street). It had 970 seats on the orchestra level and 450 in the balcony. It was not very successful in the early years, and the Great Depression forced it to close in 1931.

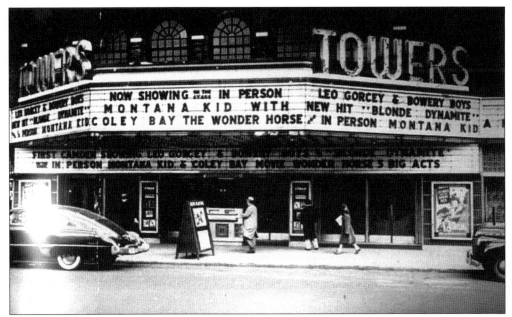

TOWERS THEATRE, CAMDEN, 1950. The Ellis chain reopened the Towers as a film and vaudeville house on Christmas Eve in 1939. From then until its closing, it was famous for its stage and screen presentations. Bands such as Vaughn Monroe and western stars including Roy Rogers and the Montana Kid often graced its stage. Ellis Theatres sold it to the Varbalow chain, which ran it until February 4, 1953. The building was razed in 1955.

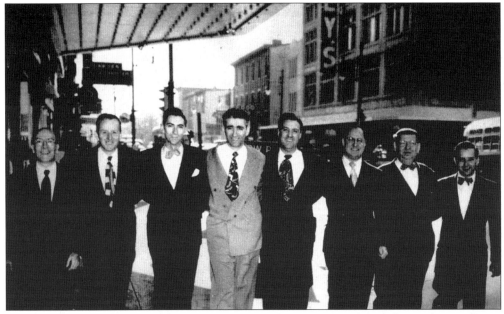

HOUSE BAND, TOWERS THEATRE, 1950S. The band members are, from left to right, ? Calbretti (drums), Art Taylor (trumpet), Edward Gormley (trumpet), Herman Sands (conductor), George Clayman (saxophone/clarinet), unidentified, Howard Beswick (piano), and Lenny DeFranco (bass). Lenny DeFranco is the brother of famous Buddy DeFranco, also from Camden. (Courtesy Jane Hamilton.)

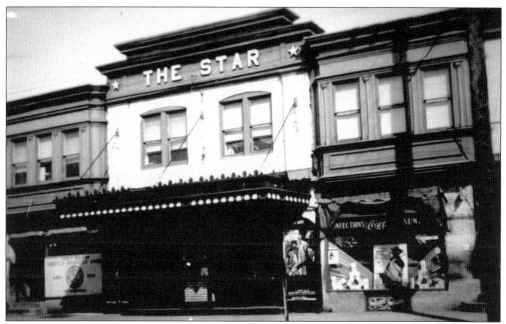

STAR THEATRE, CAMDEN, 1945. The Star, at Broadway and Viola Streets, was close to the Gloucester city border. In 1919, it had a Moller pipe organ and 704 seats. It continued to operate as a neighborhood movie theater until the early 1960s. Its nickname was "Rats," Star spelled backward. The building is still standing and is presently used as an athletic club.

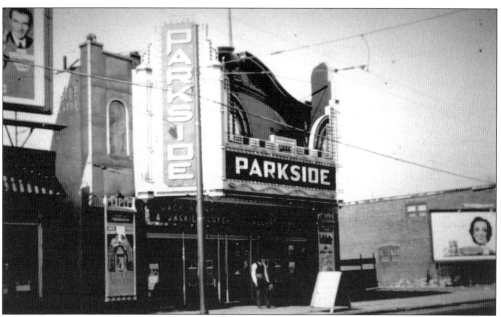

PARKSIDE THEATRE, CAMDEN, 1940. The Parkside, at Haddon and Kaighn Avenues, was built by Charles Kaufmann in 1919 and named the Forest Hill. It featured a Kimball pipe organ and 700 seats. In 1922, Handle and Rovner renamed it the Parkside and eventually sold it to Ellis Theatres. The Ellis chain continued to run it until 1964. The building is presently in use as a church.

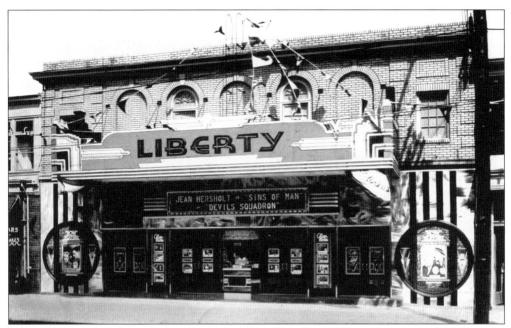

LIBERTY THEATRE, CAMDEN, 1936. Originally a Handle and Rovner theater, the Liberty, at 1502 Mount Ephriam Avenue, had 700 seats on one floor and, in 1921, featured a Moller pipe organ. The Ellis chain purchased this house and the Parkside, running both into the 1960s. The building is still standing and in use for retail space.

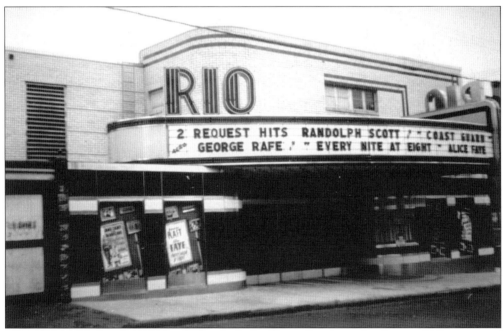

RIO THEATRE, CAMDEN, 1939. Located at 2711 River Road, in the Cramer Hill section of Camden, the Rio was one of the early Varbalow theaters. It was originally named the Auditorium and had 736 seats on one floor. The art deco building is still standing and is used as a church.

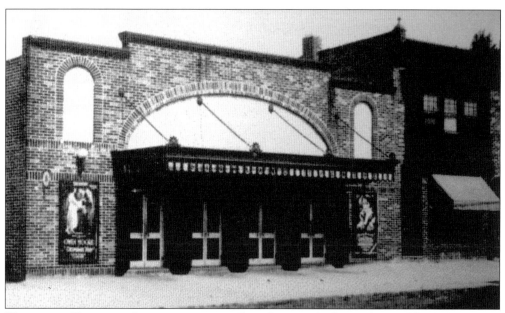

HIGHLAND THEATRE, AUDUBON, 1922. This photograph shows the Highland, located at 305 East Atlantic Avenue, with its original marquee. At that time, this area was known as the Haddon Highlands, from which the theater got its name. It had 723 seats. In 1923, a Moller pipe organ was installed. It was built next to Schnitzler's Hall, also known as the Audubon Opera House, which was the site of the first "flickers" in Audubon.

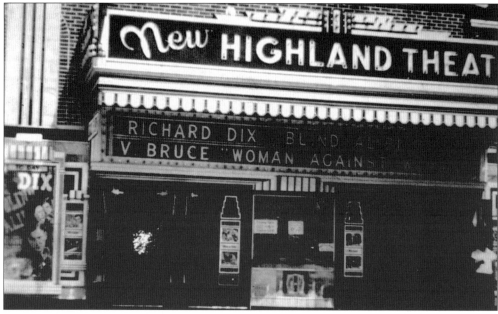

HIGHLAND THEATRE, AUDUBON, 1938. Sporting a new marquee and now known as the New Highland, the theater was sold by owner Abraham Brown to the Varbalow chain. The Highland was a successful neighborhood theater in what became the Orston section of Audubon until closing in the mid-1950s. Patrons would often stop in the Orston Sweet Shoppe after the show. The theater building is now a Masonic temple.

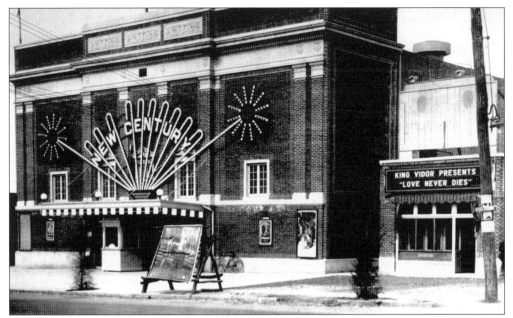

CENTURY THEATRE, AUDUBON, 1921. Built in 1921 with stock issued by the South Jersey Amusement Company, the theater was located at the White Horse Pike and Kings Highway in Audubon. The Century had its own electricity generating plant, artesian well for air cooling, and a Wurlitzer pipe organ. It had 1,100 seats on the orchestra level with an additional 350 seats in the balcony. (Courtesy Paul W. Schopp collection.)

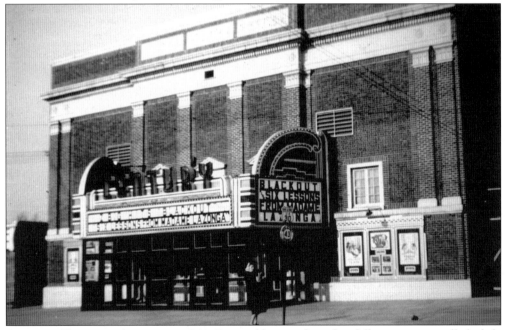

CENTURY THEATRE, AUDUBON, 1941. Pictured here with its first full marquee, installed while under Hunt Theatre Management, the theater featured a six-man house orchestra and three full-time stagehands. A new Moller organ installed in 1928 replaced the original Wurlitzer. In the 1940s, the Century was sold to the Varbalow chain. (Courtesy Gary Feldman collection.)

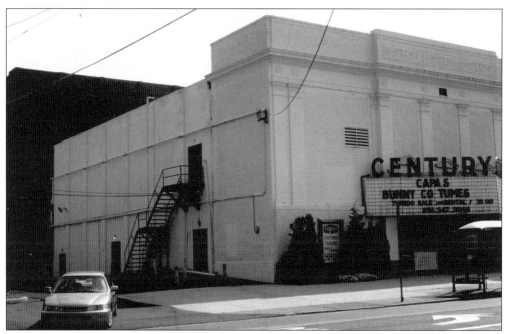

CENTURY THEATRE, AUDUBON, 1985. The Varbalow chain (Savar) remodeled the theater late in the 1960s, installed a new V-shaped marquee, and changed the name to the Coronet. The Coronet closed in 1979 and was sold to the Campbell family of Audubon. They put the original "Century" name back on the marquee and, after trying it as a concert venue, decided to use it as a warehouse for their Capas theatrical business.

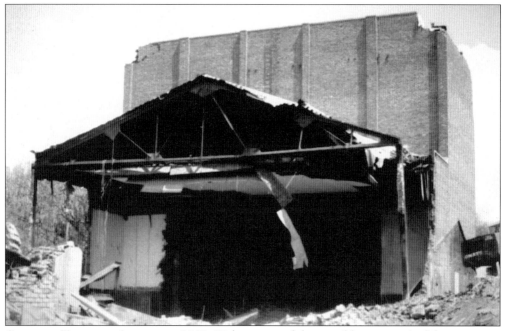

CENTURY THEATRE, AUDUBON, 2003. Eighty years of theatrical history in Audubon came to an end as the Century was torn down in April 2003 to permit construction of a chain drugstore. Less than two years later, the drugstore closed, and the building was vacant.

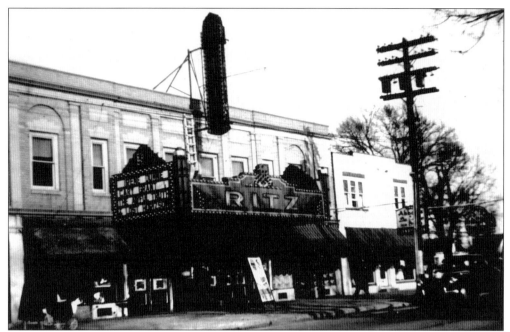

RITZ THEATRE, OAKLYN, 1937. Located on the White Horse Pike, the Ritz opened in 1927 with 600 seats and featured a Gottfried pipe organ. In the 1950s, it was South Jersey's premier foreign film venue. It closed as a movie house in the 1970s. Today the Ritz is home to Puttin' on the Ritz, a successful live, subscription theater company.

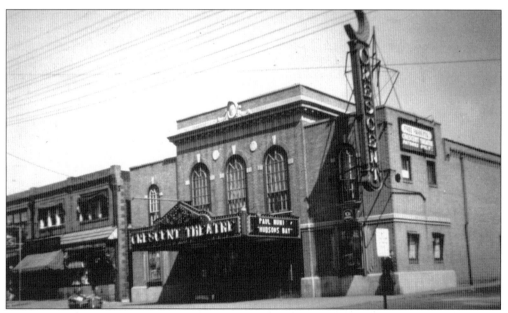

CRESCENT THEATRE, HADDON TOWNSHIP, 1941. The Crescent, also shown on the cover, was located on Mount Ephriam Avenue in West Collingswood. It opened in 1929 as part of the Hunt chain and was later sold to Ellis Theatres. They ran it until it closed in the 1970s. The building is still standing and is used as an automobile repair and tire center. Note the crescent moon atop the vertical sign.

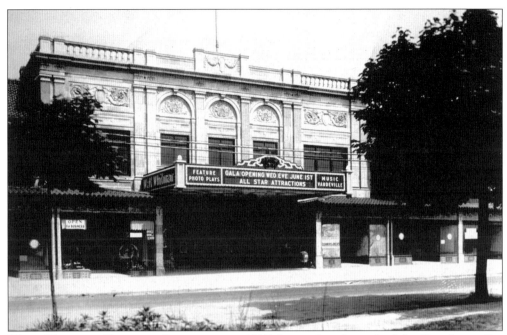

WALT WHITMAN THEATRE, PENNSAUKEN, 1927. Located at the end of the Camden trolley line, at Forty-sixth Street and Westfield Avenue, the Walt Whitman was a true movie palace. Built by the Varbalow chain, it had 1,058 seats, including the balcony, a marble grand staircase to the mezzanine level, and a mighty Wurlitzer pipe organ. (Courtesy Robert Semler.)

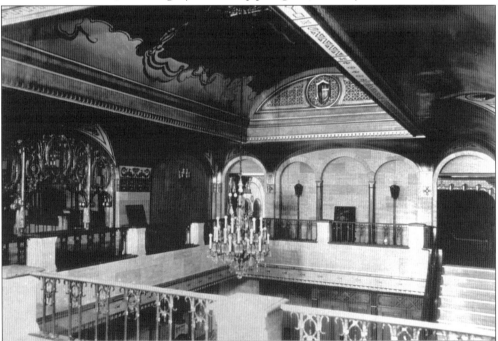

WALT WHITMAN THEATRE INTERIOR, 1927. This photograph shows the mezzanine level, which permitted a view of the main lobby below and facilitated entrance to the balcony seats. Note the ornate furnishings and the chandelier.

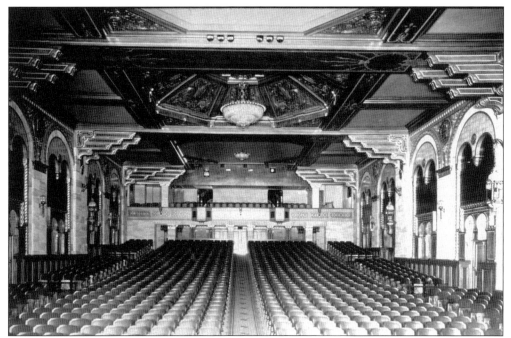

WALT WHITMAN THEATRE AUDITORIUM, 1927. This is a view of the auditorium from the stage. The balcony seats can be seen just under the projection room ports, as well as the entrances to the mezzanine rest area. (Courtesy Robert Semler.)

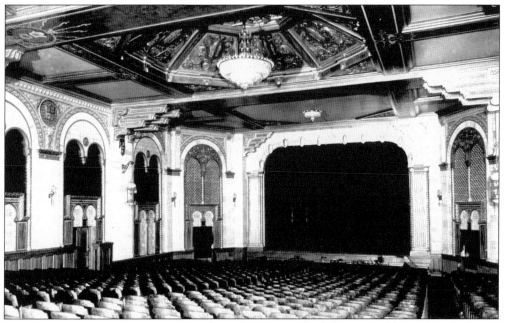

WALT WHITMAN THEATRE STAGE, 1927. This view is from the rear of the auditorium. Note the organ pipe chamber swells on each side of the elaborate proscenium and the huge main chandelier. The building covered the entire block, including several retail spaces, and housed the main offices for the Varbalow (Savar) chain. This grand building was razed in the 1970s.

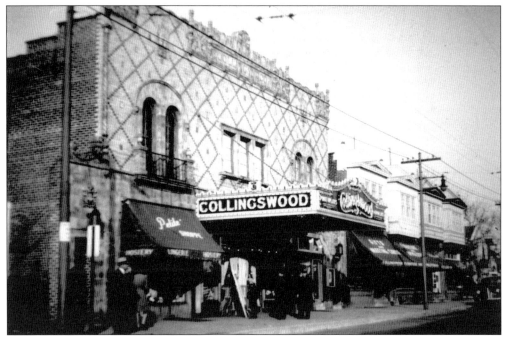

COLLINGSWOOD THEATRE, COLLINGSWOOD, 1945. Located at 823 Haddon Avenue, the Collingswood was opened by Handle and Rovner in 1920. The theater had 1,200 seats on one floor and a full stage. The opening attraction was *The Riddle Woman* starring Geraldine Farrar, with accompaniment on the Moller pipe organ. The theater was sold to the Stanley-Warner Company in 1934 and to the Varbalow chain in 1948. It closed in the 1960s and is in use today as retail and office space.

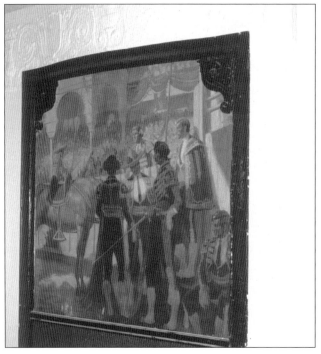

COLLINGSWOOD THEATRE MURAL 1920. The Collingswood was decorated in a Spanish motif featuring wrought iron balcony railings on the façade and elaborate plaster cornices throughout. There were Mediterranean-style furnishings in the lobby, and hand-painted murals of matadors and Spanish scenes on the Auditorium walls. This photograph shows a section of cornice work and one of the murals.

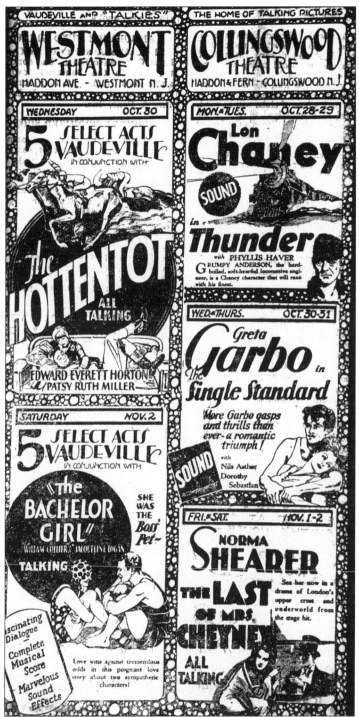

NEWSPAPER ADVERTISEMENT FOR THE COLLINGSWOOD AND WESTMONT THEATRES, 1929.
"Talkies" were hot by now. Note the top banner for each theater, especially the combination of vaudeville and talkies for the Westmont. Greta Garbo's *The Single Standard* was a silent film, but as audiences were demanding sound, it was presented with synchronized music and sound effects.

ANNIVERSARY PROGRAMME

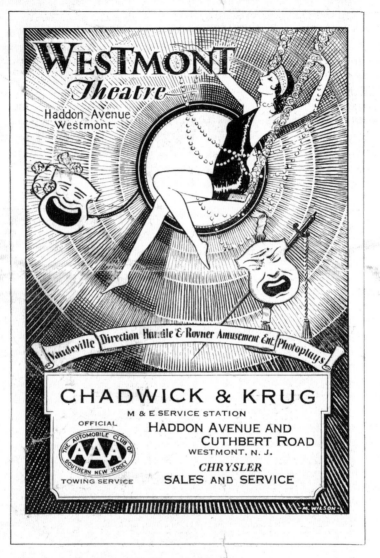

WESTMONT THEATRE PROGRAM, 1928. This is the cover of the 12-page anniversary program for the Westmont Theatre week beginning September 3, 1928. Note that the banner features vaudeville and photoplays. Inside is a greeting from J. M. Rappaport, general manager, and program listings for the week. Monroe Hilbert is featured at the organ console and the house orchestra for the stage show. The films for the week include *Road House*, *The Vanishing Pioneer*, *Name the Woman*, *The Leopard Lady*, and Clara Bow in *Ladies of the Mob*.

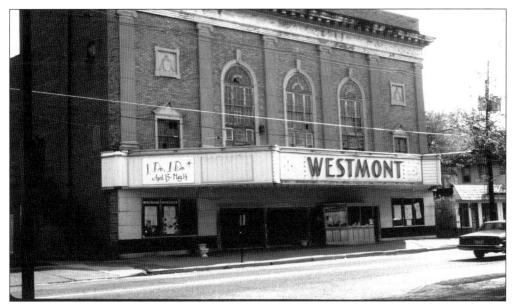

WESTMONT THEATRE, HADDON TOWNSHIP, 2000. Handle and Rovner opened the Westmont Theatre on Haddon Avenue in 1927. This vaudeville and film house had 1,200 seats, split between the orchestra level and a balcony. The Westmont featured its Lenoir pipe organ at every performance. Stanley-Warner assumed control in 1934, Varbalow in 1947, Milgram Theatres in the 1960s, and, finally, Budco Theatres. As of 2005, the Westmont is still standing, with plans for restoration underway.

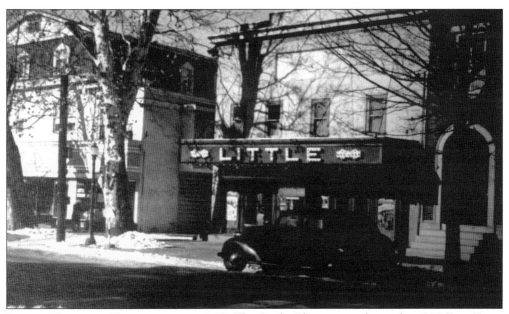

LITTLE THEATRE, HADDONFIELD, 1945. The Little Theatre was located at 207 East Kings Highway on a property dating to 1742, known then as the Griscom-Cooper House. It became a theater in 1913, known as the Haddonfield Photo Play House. After several name changes, it became the Little. It featured 307 seats on the main floor and 43 in the balcony. Closed in the 1950s, it is now used for retail space.

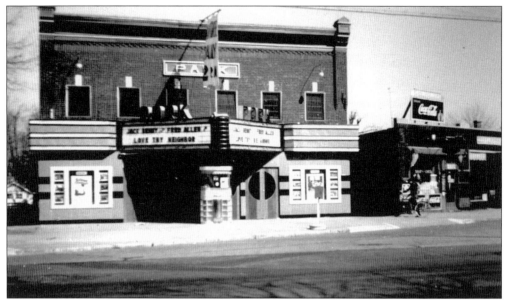

PARK THEATRE, MERCHANTVILLE, 1941. Located at 25 West Park Avenue, the theater opened in 1913 with 556 seats. A Moller pipe organ was installed in 1920. By 1945, the Park was part of the Frank Theatre chain and operated into the 1950s. The building is in use as a carpet showroom in the original lobby, with the auditorium used as a warehouse. The original proscenium and tin ceiling are still intact.

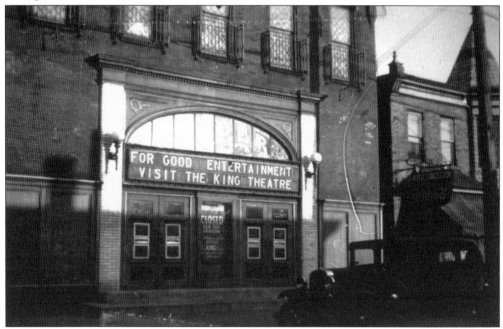

LEADER THEATRE, GLOUCESTER, 1941. Built specifically for motion pictures by "Mommy" Hayes this 600-seat theater, at 19 North Burlington Street, opened in 1913. Hayes also owned the Opera House, at 27–29 Burlington Street, where she added movies to her mix of vaudeville and burlesque in 1912. The Opera House closed before converting to sound. The Leader was closed and razed shortly after this photograph was taken.

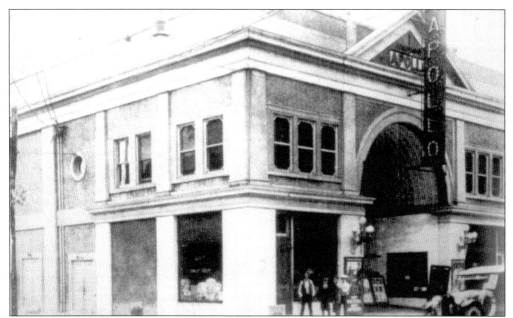

APOLLO THEATRE, GLOUCESTER, 1920. The Apollo opened in 1919 at King and Somerset Streets. It featured a Muller organ, a full stage, and a total of 847 seats. (Courtesy Paul W. Schopp collection.)

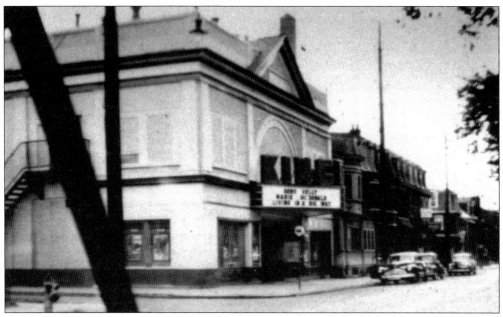

KING THEATRE, GLOUCESTER, 1947. In 1939, the Apollo was renamed the King Theatre, and during this period, the original organ was replaced with a Wurlitzer. The Varbalow circuit took over management and ran it through the mid-1960s. After Varbalow closed the house, several independent operators tried to use it as a concert venue, but with little success. The building was razed in the 1970s.

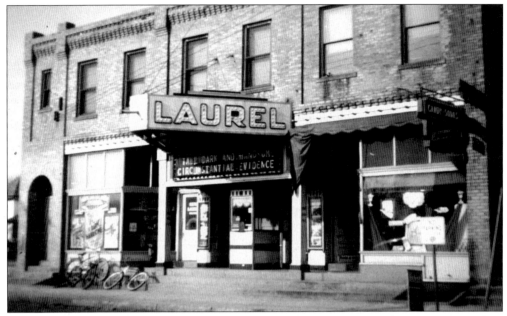

LAUREL THEATRE, LAUREL SPRINGS, 1945. A Sam Frank theater, the Laurel opened in 1922 with 400 seats. The theater ran into the late 1950s before falling victim to the impact of television. During this period, the projectionist, Roy Foxhill, ran a television repair shop in one of the building's retail stores. After the theater closed, the building was converted into apartments. It burned to the ground in 2002.

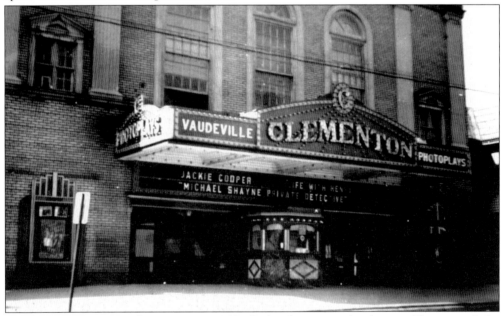

CLEMENTON THEATRE, CLEMENTON, 1940. Built adjacent to the famous Clementon Lake Amusement Park in 1927 by Handle and Rovner, the Clementon was a scaled-down model of Camden's Stanley Theatre. It had 897 seats at the orchestra level, 323 in the balcony, and a full stage where it hosted major live acts through the 1940s. From 1934 until closing in the 1960s, it was part of the Stanley-Warner chain. It was razed in 1970.

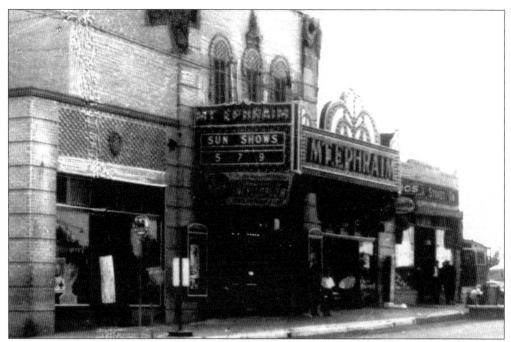

MT. EPHRIAM THEATRE, MOUNT EPHRIAM, 1939. Located at the Black Horse Pike and Kings Highway, the theater opened with 774 seats and a Kilgen pipe organ on Thanksgiving Day 1930. Helen Morgan and Abbott and Costello were typical of the big names that appeared on its stage. The theater was lovingly operated for 70 years by the Harwan family, builders and owners. Renamed the Harwan in 1970, it closed in 2001.

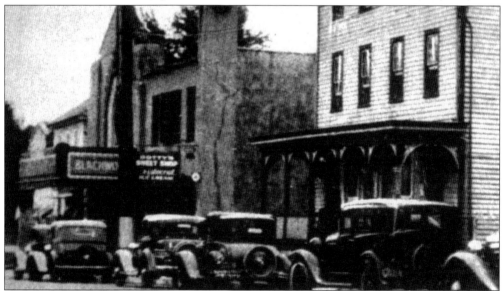

BLACKWOOD THEATRE, BLACKWOOD, 1935. Located on the Black Horse Pike, the Blackwood Theatre was built and operated by the Harwan family in 1927. This ornate 500-seat house featured a Moller organ and a small stage. In 1979, the original marquee had to be removed, and the theater was renamed the Movies. The building was razed in 1991, and the town council dedicated the Alex Harwan Blackwood Theatre Park on the site.

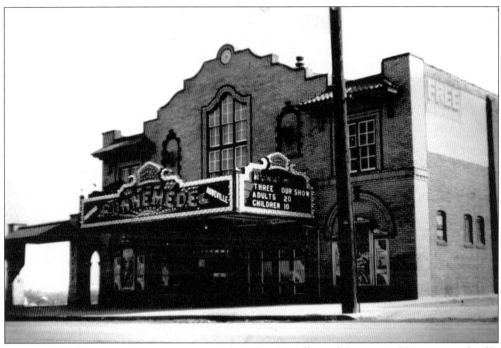

RUNNEMEDE THEATRE, RUNNEMEDE, 1941. This Handle and Rovner 1,500-seat vaudeville and film house opened in October 1928 with *Glorious Betsey* starring Conrad Nagle. Featuring a 2,000-car parking lot, it was too much theater for its location, and even stage appearances by Red Skelton, Buddy Ebson, and Al Jolson failed to make it a financial success. It won approval for Sunday performances but was still forced to close in 1932.

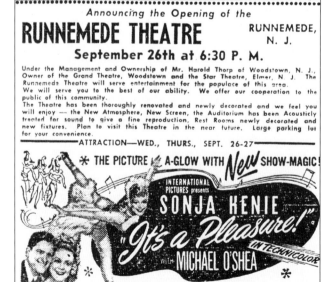

RUNNEMEDE THEATRE ADVERTISEMENT, 1945. The theater had several unsuccessful attempts at life before Harold Thorp tried again in September 1945. The Runnemede continued to struggle with its size until a fire brought the final curtain down in February 1950. The building and grounds became home to a car dealership until another fire forced demolition in 2002. (Courtesy the Courier-Post.)

Two

BURLINGTON COUNTY

It is impossible to discuss the history of movie theaters in New Jersey's largest county without acknowledging the contributions of three generations of the Fox family, for Burlington County was their turf. The patriarch, Jacob B. Fox (known as J. B.), came to America in 1902 from Russia. His first theater venture in 1910 was the Columbia in Philadelphia, but he quickly realized the potential for expansion across the river, and by 1923, he was operating eight theaters in South Jersey, most in Burlington County. Burlington City was home to three of these, the Birch Opera House, the Burlington Auditorium, which J. B. renovated and renamed the Fox in 1923, and the High Theatre, built by J. B.'s son, Melvin J., in the 1950s. Melvin's son Steven B. joined the management team in the late 1950s.

J. B. followed his Burlington City venture with the purchase of Foresters Hall in Riverside, also known as the Forest Theatre. He opened it as the Fox, Riverside on Christmas Day 1916. He remodeled the house in 1925, installing a Moller pipe organ, and again in 1929 after a minor fire—each time with a gala grand opening. In 1950, Melvin built what was then the state-of-the-art Mt. Holly Theater. Eventually the Fox dynasty owned, operated, or had an interest in over 25 theaters in the region, including the Roxy in Maple Shade and the Criterion in Moorestown. The last new indoor theater they built was the Fox Theatre in Levittown (Willingboro today), the only theater between Philadelphia and New York to feature 70-millimeter projection when it opened in 1957. The Foxes would later build an outdoor theater, the Pennsauken Drive-In.

Other theaters of interest in Burlington County include the Medford Theater built in 1903, still standing today as Culture Hall, and the Plaza built at the Moorestown Mall by the Savar Corporation. The Plaza was the first theater in the Delaware Valley to have stadium seating, chosen to reduce mall "square footage rental," not to improve sight lines. The construction of the Plaza led to the repeal of the Moorestown blue laws to permit Sunday screenings.

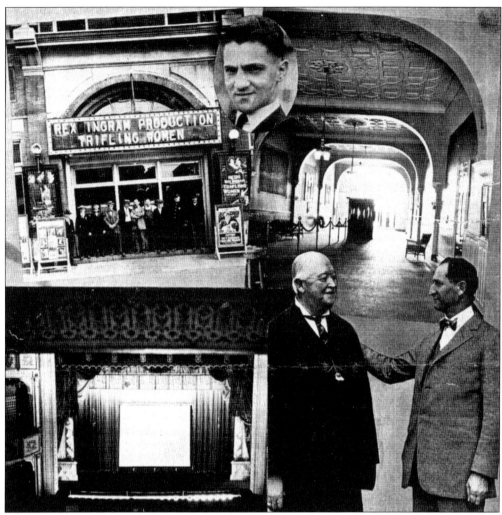

FOX AUDITORIUM, BURLINGTON CITY ANNOUNCEMENT, 1923. Pictured is a trade paper announcement for the purchase and remodeling of the Auditorium Theatre by J. B. Fox in October 1923. In the upper left is the new exterior, lower left is the stage setting, and the right side shows Thomas S. Mooney, mayor of Burlington (left) with J. B. Fox in the lobby area. In the inset is Samuel Shelly, remodeling contractor.

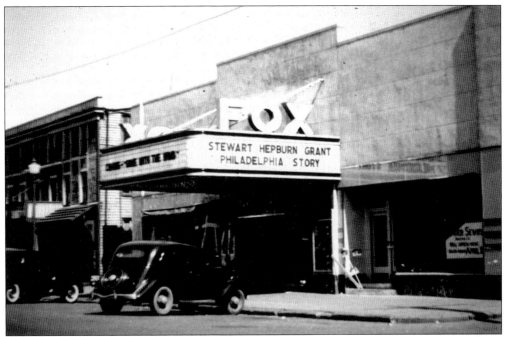

FOX THEATRE, BURLINGTON CITY, 1941. After purchasing the Auditorium, located at 410 High Street, in 1923 and renovating it with plans designed by architect David Supowitz, J. B. Fox renamed the theater the Fox. It featured a fully equipped stage, orchestra pit, and 2,000 seats. In the early 1950s, J. B.'s son Melvin J. Fox built the 700-seat High Theatre at 409 High Street, just opposite the Fox.

FOX THEATRE, BORDENTOWN, 1941. The theater originally opened in 1915 with 680 seats on one level. It was purchased several years later by J. B. Fox, renamed the Fox Bordentown, and ran successfully into the mid-1950s.

FOX THEATRE, MOUNT HOLLY, 1941. Originally called the Mt. Holly Opera House (c. 1907), the theater was remodeled and renamed by J. B. Fox. He held a gala opening on September 23, 1929, with a talkie titled *They Had to See Paris* starring Will Rogers. The theater had 726 seats on the orchestra floor and an additional 209 seats in the balcony. (Courtesy Gary Rothman.)

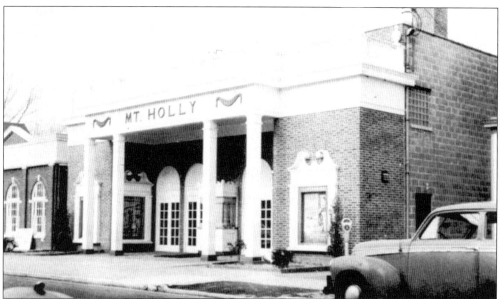

MT. HOLLY THEATRE, MOUNT HOLLY, 1950. Once again, J. B.'s son, Melvin, opened a new theater close to the town's original Fox Theatre. On April 27, 1950, the 935-seat Mt. Holly opened with a special showing of Alfred Hitchcock's *Stage Fright*. It was the first Fox-owned theater to advertise a parking lot, a response to the new suburban mobility. The Mt. Holly continued to operate into the 1970s.

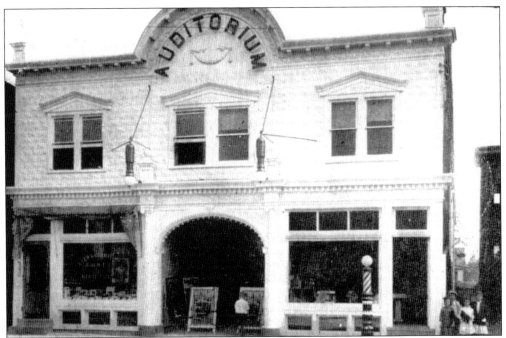

AUDITORIUM, RIVERSIDE, 1910. Like Burlington City, Riverside had a community building known as the Auditorium. This, the first showplace for motion pictures in the city, was built in 1907 at 20–22 Scott Street and was used for many community functions in addition to motion pictures. It ceased to be home to film entertainment after the opening of the Fox Theatre in 1916. (Courtesy Paul W. Schopp collection.)

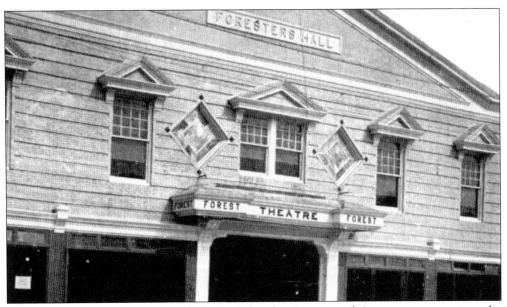

FORESTERS HALL, RIVERSIDE, 1912. Built by the Foresters of America organization, the building at 223 Pavillion Avenue that had 1,000 seats was also known as the Forest Theatre. In 1916, it was purchased by J. B. Fox, who renamed it the Fox Theatre and held a gala opening on Christmas night of that year. (Courtesy Paul W. Schopp collection.)

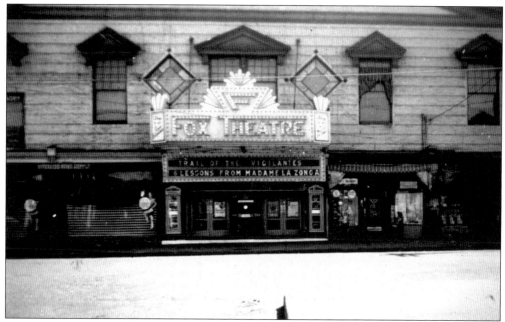

FOX THEATRE, RIVERSIDE, 1940. In 1925, nine years after purchasing the original Foresters Hall, J. B. Fox remodeled the building and installed a Moller pipe organ. He remodeled again, after a minor fire in 1929, and held an invitational reopening on Wednesday, August 29, 1929. The Fox continued to be successful until television reduced its audience, forcing it to close in the late 1950s. It burned to the ground several years after closing.

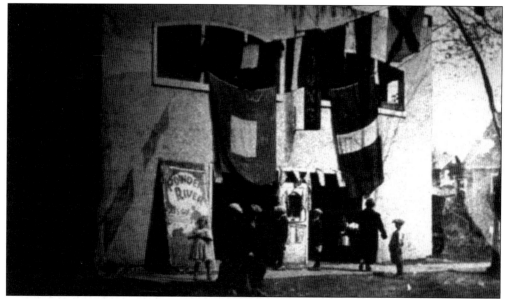

LOUX'S PALACE, MAPLE SHADE, 1915. The Palace, also known as the "Red Onion," was located on South Forklanding Road, behind Petitt's Drug Store, and was opened by the Loux family in 1915. In 1922, a community hall, also known as the Victory Café, was used for motion pictures after the Palace closed and before the Roxy Theatre opened on Main Street. (Courtesy Maple Shade Historical Society.)

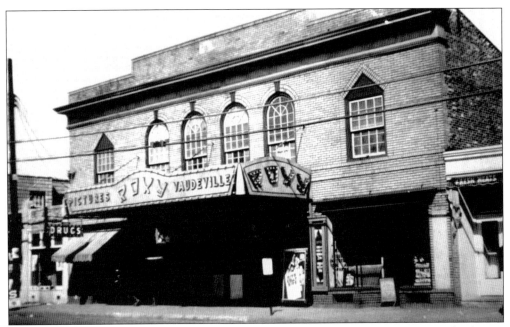

ROXY, MAPLE SHADE, 1941. J. B. Fox built the Roxy at 13 East Main Street in 1926. The theater had 692 seats on the main floor, plus an additional 56 located in a small balcony. It featured a fully equipped stage with a fly loft for vaudeville. Fox added a Page pipe organ in 1928, making the Roxy a true "palace."

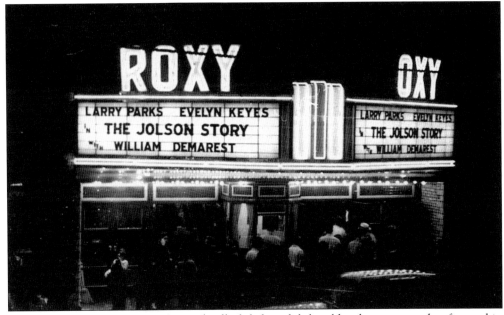

ROXY, MAPLE SHADE, 1946. As vaudeville faded, so did the old style marquees that featured it. Here is the Roxy with its updated, modern marquee and a crowd of patrons buying tickets. The Roxy remained in the Fox holdings until it was razed in the 1960s, although it was leased and operated for a period of time by the Savar (Varbalow) Corporation and, later, by Edward Karpen.

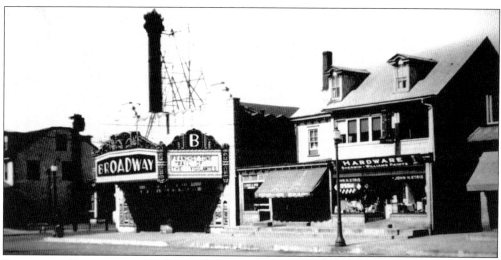

BROADWAY, PALMYRA, 1941. Located at Broad Street and Leconey Avenue, the Broadway opened in 1926, with 750 seats on one floor. Purchased by the Varbalows on December 31, 1933, it reopened as their sixth theater on Tuesday, January 16, 1934, with Joe E. Brown in *Son of a Sailor*. It continued to operate under Milgram management into the 1960s. The building remains standing and is now used as a church.

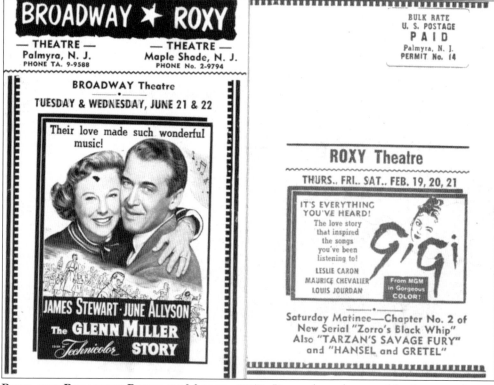

ROXY AND BROADWAY PROGRAM MAILER, 1958. Pictured are front and back covers from a typical weekly program. Note that movies played a limited number of days to permit people to attend more often. Saturday matinees were always aimed at children, with special features, serials, and short subjects.

CRITERION, MOORESTOWN, 1941. Built by J. B. Fox in 1920, it had 474 seats. A Marr and Coulton pipe organ was added in 1927. The theater closed in the mid-1950s, another casualty of the novelty of television. David and Aaron Grossman reopened it in 1959 and called it the Carlton. They operated it as a sophisticated art theater until 1963.

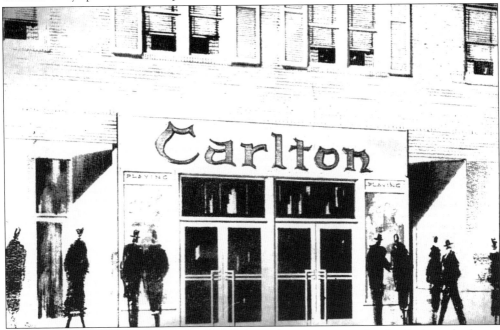

CARLTON, MOORESTOWN, 1959. This sketch shows the new entrance for the Carlton, the former Criterion. After being sold by the Grossmans, it was renamed the Moorestown Playhouse and enjoyed several successful years of live theatrical production. The Moorestown Playhouse brought in touring companies featuring major stars, including Geraldine Page in *The Glass Menagerie* and Danny Meehan in *Roar of the Greasepaint, Smell of the Crowd*.

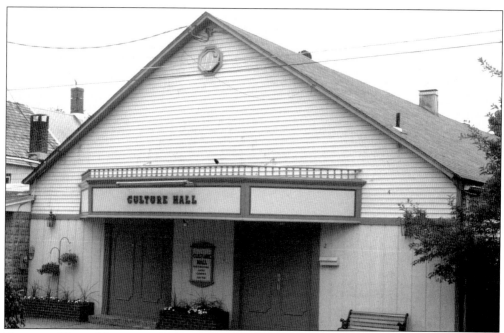

CULTURE HALL, MEDFORD, 1999. Culture Hall, at 2 Friends Avenue, began life in 1903 as a community hall, built by the Warner family. Admission for movies ranged from 7¢ in 1903 to 13¢ by 1913, when it was commonly called the Warner. By the Second World War, it was the Medford, and its final film performance was on July 2, 1951. The building is still used today for community functions.

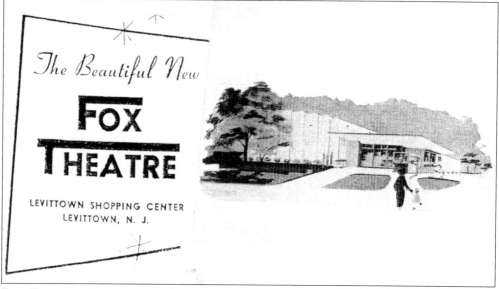

FOX THEATRE, LEVITTOWN, ANNOUNCEMENT, 1960. This is an artist's rendering and announcement for the new 1,200-seat Fox Theatre on Route 130 in Levittown (later named Willingboro). This Fox was the last indoor theater the company built and was the first in South Jersey equipped for 70-millimeter projection. The Fox was twinned in the 1970s. It closed and was torn down in the 1980s.

Three

DOWN THE SHORE

While most coastal residents may talk of going "to the beach," in South Jersey, people always go "down the shore"! The South Jersey shore, which primarily includes the barrier islands from Atlantic City to the city of Cape May, has a unique atmosphere and a mystique that cannot be duplicated any place else. Because the resorts of these islands were major tourist meccas, drawing thousands of visitors each summer, they were home to many grand movie palaces. The movie studios released their biggest and newest films to these oceanside venues all summer long. At one time, Atlantic City had over 30 theaters, ranging from the huge Warner Theatre and the multi-theater complex of Steel Pier on the famous boardwalk, to smaller specialty theaters like the Alan and Charles located on Atlantic and Pacific Avenues. Most of the major theater chains owned or leased locations throughout the entire city. Sadly, today, all of these are just memories. As of 2005, with the exception of a new IMAX theater in a casino complex, Atlantic City is totally without a motion picture theater.

While Ocean City was home to 10 theaters over the years, only the Strand and the Moorlyn, both on the boardwalk, remain today. For many years, most film exhibition in the city was controlled by the Shriver family, famous for their saltwater taffy stores on the boardwalk. The Shrivers later sold their holdings to the Frank Theatre Company of Pleasantville, which recently renovated the Strand and the Moorlyn into state-of-the-art multiplexes.

From Wildwood down to Cape May, William C. Hunt was the king of entertainment. He built everything from amusement piers to theaters of all sizes. At one time, Hunt owned or operated over seven theaters in the city of Wildwood alone, with the boardwalk Strand being his premier location. All of these theaters are now gone, with the exception of the Strand, which now runs as an independently owned, multi-screen venue in the summer.

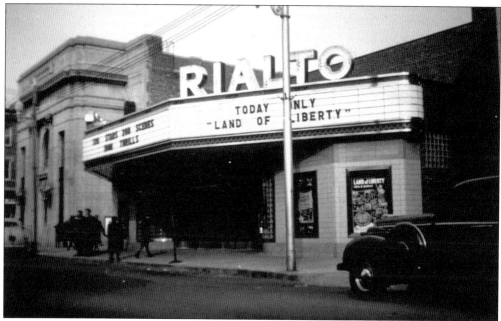

RIALTO THEATRE, PLEASANTVILLE, 1941. Pleasantville lies on the mainland, just outside Atlantic City. This town was home to the Rialto Theatre, which opened in the 1920s with 888 seats and featured a Wurlitzer pipe organ. It was a typical neighborhood house, closed and razed by the 1960s.

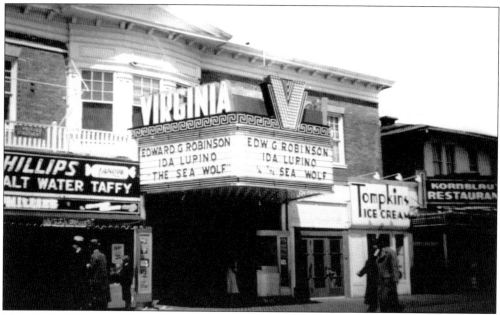

VIRGINIA THEATRE, ATLANTIC CITY, 1941. Located on the boardwalk at Virginia Avenue, across from Steel Pier, the 947-seat Virginia Theatre opened in 1916, featuring an Austin pipe organ. The Austin was replaced with a Kimball organ in 1924, and by 1956, the Virginia would boast the latest 70-millimeter technology for the summer blockbuster *Around the World in 80 Days*. The building was razed for casino construction in the 1980s.

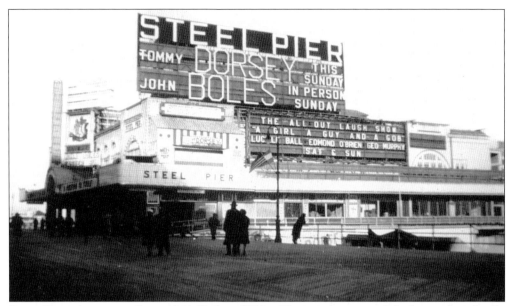

STEEL PIER, ATLANTIC CITY, 1941. Built in 1900 at Virginia Avenue and the famous boardwalk, the Steel Pier is one of the most recognizable landmarks of Atlantic City. Movies arrived as an occasional attraction in the early 1900s. By the 1930s, there were three theaters on the pier: the Music Hall (2,250 seats) with a vaudeville and film format, the Casino (2,000 seats), and the Ocean (1,406 seats).

PROGRAM

———

Monday, July 2d

———

MARTINI'S SYMPHONY ORCHESTRA—ETTORE MARTINI, Director

Afternoon, 3.30 o'clock, in the Arcade.

1. Overture—Poet and Peasant ...Suppe
2. Waltz—Sentier Fleuris ...Waldteufel
3. Operetta—Oh Boy ..Kern
4. Tenor Solo—Last Rose of Summer ...Balfe
 Wilbur Herwig
5. Grand Opera—Tosca ...Puccini
6. Aubade Printaniere ...Lacombe
7. Bass Solo—Best of All ..Cowles
 John Vandersloot
8. Ballet from Faust ...Gounod

Evening, 7.45 o'clock, in the Casino.

1. Egyptian Ballet ..Luigini
2. Serenata ...Drigo
3. Operetta—Miss Springtime ...Kalman

Cake Walk, Ball Room, 8.30 o'clock.
Motion Pictures, Ball Room, 3.30 and 9.15 o'clock.

STEEL PIER PROGRAM, 1917. This is a section of the weekly program for July 2, 1917. Note that "motion pictures," without any specific titles, are listed as one of the attractions in the ballroom for that day. It would be several more years before film became a bigger attraction at the theaters on the pier.

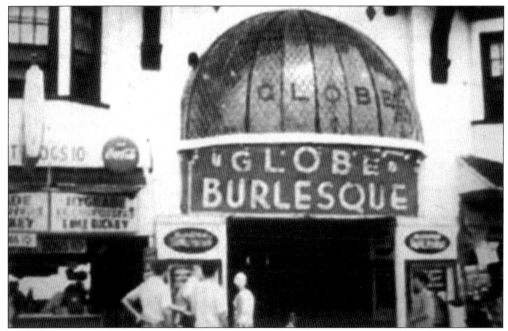

GLOBE THEATRE, ATLANTIC CITY, 1950. On the boardwalk at St. Charles Place, the Globe opened in the 1900s as a vaudeville house. In 1926, it was the first in the city to install Vitaphone for the area premier of *Don Juan*, Warner Brothers' first sound film. After the Warner Theatre opened in 1928, the Globe became a major burlesque theater and operated as such until closing in the 1960s.

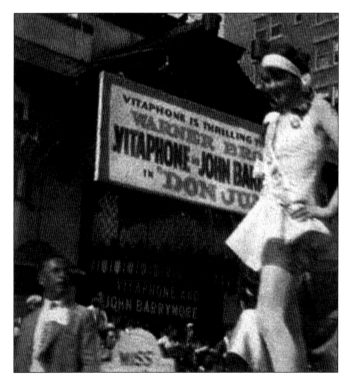

GLOBE THEATRE, ATLANTIC CITY, 1926. This photograph shows the 1926 Miss America parade passing the Globe Theatre with its marquee and façade sign announcing Vitaphone and John Barrymore in *Don Juan*.

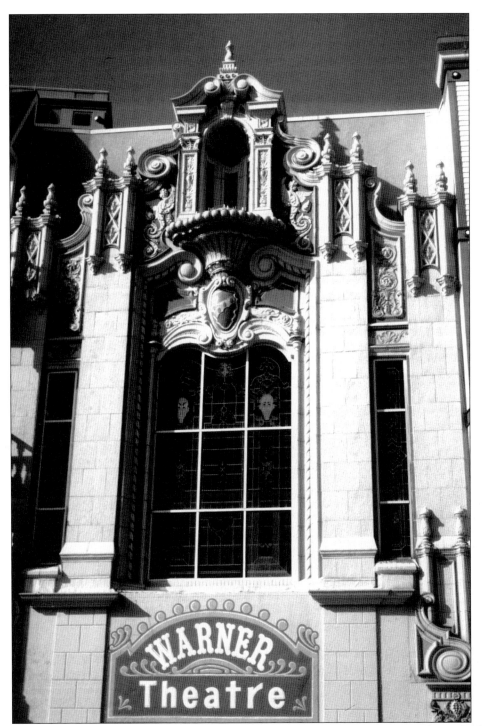

WARNER THEATRE FAÇADE, ATLANTIC CITY, 2004. Although the auditorium and main lobby of the Warner were razed for casino construction, its original façade remains intact. Listed on the National Register of Historic Places, it has been incorporated into Bally's Casino boardwalk frontage, providing a memory of Atlantic City's past.

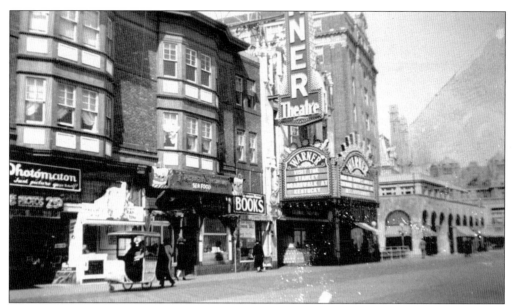

WARNER THEATRE, ATLANTIC CITY, 1948. Designed by architects Hoffman and Henon in a Spanish motif, this atmospheric theater opened in 1928 on the boardwalk at Arkansas Avenue. The largest in the city, it had 2,626 orchestra seats, 1,251 balcony seats, 310 loge seats, and a Wurlitzer pipe organ. In the 1950s, the name was changed to the Warren, to use the same marquee letters, and it became a live venue. It was razed in the 1970s.

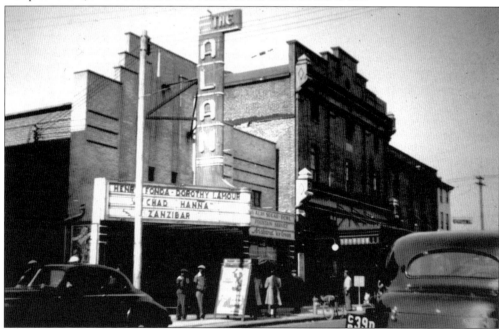

ALAN THEATRE, ATLANTIC CITY, 1941. Like the Royal in Philadelphia, the 600-seat Alan, at Arctic and Kentucky Avenues, was unique in that it specialized in movies made by black directors especially for black audiences. They were but 2 of over 700 such theaters across America. Films such as Oscar Micheaux's *Body and Soul* and Edgar G. Ulmer's *Moon over Harlem* brought the realities of social issues to the screen.

CAPITAL THEATRE, ATLANTIC CITY, 1941. The Capital, located at Atlantic and Maryland Avenues, opened in 1921 with 1,139 seats and a Robert-Morton pipe organ. In addition to the boardwalk locations, many of Atlantic City's 30 theaters were found on either Atlantic or Pacific Avenues. It is hard to believe, but all of Atlantic City's theaters, including the Capital, are now just memories.

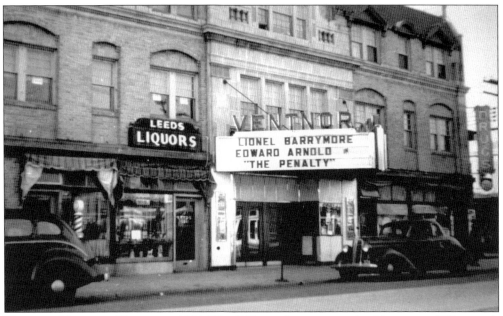

VENTNOR THEATRE, VENTNOR, 1941. This 968-seat theater opened at Ventnor and Weymouth Avenues in 1921. It was remodeled in 1936 and converted to a twin in the 1970s. Once part of the Frank Theatre chain, the Ventnor continues to operate today. It recently had new seating installed and is the only remaining theater left on the barrier island that includes Atlantic City.

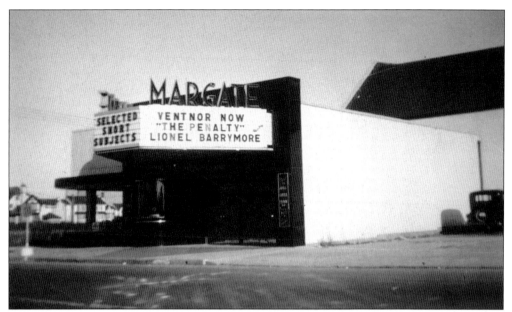

MARGATE THEATRE, MARGATE, 1941. The 800-seat Margate was built in 1938 and was part of the Frank Theatre chain. As in many of the resort shore towns, the Margate was primarily a summer operation. It is shown here off-season, promoting its "sister" house, the Ventnor, a short ride north. The Margate was also converted to a twin in the 1970s, closed in the 1990s, and eventually razed for condominiums.

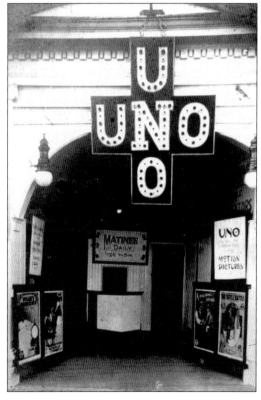

UNO THEATRE, OCEAN CITY, 1908. Built by Ira Champion on the boardwalk at Moorlyn Terrace in 1908, the Uno was the first building in Ocean City designed specifically for the presentation of motion pictures. Champion sold it to the partnership of Roscoe Faunce and Roy Darby. They closed it before the sound era to eliminate competition for the new Faunce's boardwalk theater. (Courtesy Senior Studios.)

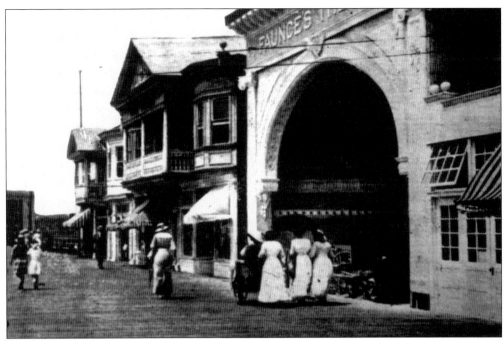

FAUNCE'S THEATRE, OCEAN CITY, 1909. D. Roscoe Faunce built his first theater on the 900 block of the boardwalk shortly after the Uno opened. It was later renamed the Plaza, and then the Colonial, before being destroyed in the October 1927 boardwalk fire. A Wurlitzer pipe organ had just been installed for the 1927 summer season.

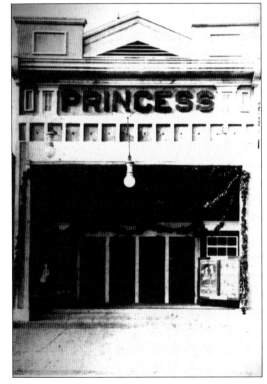

PRINCESS THEATRE, OCEAN CITY, 1920. Located at 834 Asbury Avenue, the Princess opened around 1910 and was the only Ocean City theater not on the boardwalk. It was very popular with local residents, as it remained open two nights a week throughout the winter months. The Princess closed without ever installing sound equipment and, today, is retail space. (Courtesy Senior Studios.)

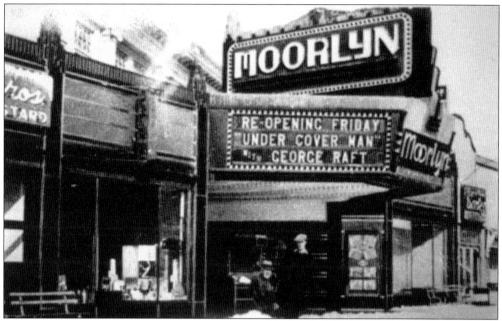

MOORLYN THEATRE, OCEAN CITY, 1932. Built in 1905 as Moore's Bowling Casino, the building had a dance hall on the second level. In 1923, the bowling alley was converted to a 1,750-seat theater with a Moller pipe organ. The Moorlyn survived the 1927 boardwalk fire but had to be moved 300 feet east to permit boardwalk access. It was twinned in the 1970s and later updated to a multiplex by Frank Theatres.

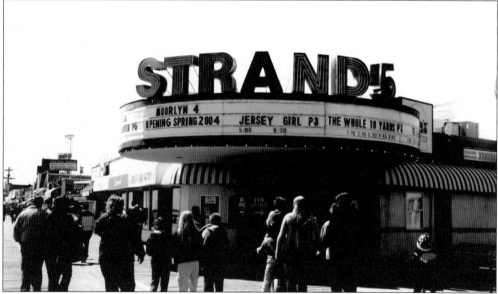

STRAND THEATRE, OCEAN CITY, 2004. The No. 5 was added to the original 1938 marquee when the large 1,450-seat theater was converted to multiple screens in 1989. Located on the boardwalk at Ninth Street, designed by Armand Caroll, the Strand was the flagship for William Shriver Theatres. It opened with Bob Hope in *Give Me a Sailor*. Now a Frank theater, it features stadium seating and digital sound.

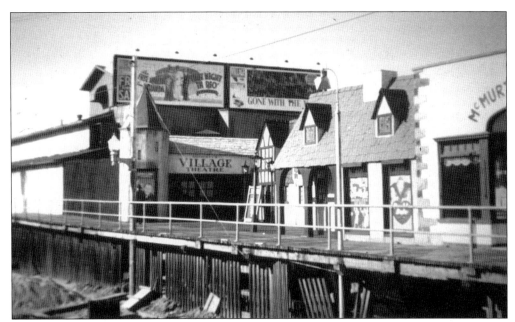

VILLAGE THEATRE, OCEAN CITY, 1941. Located at Eighth Street and the boardwalk, the Village Theatre began life in the early 1900s as Doughty's Pier on the ocean side of the boardwalk. When the boardwalk was rebuilt 300 feet east following the 1927 fire, this 1,100-seat theater found its stage end facing the boardwalk! It was moved and completely turned around inside. Twinned in 1990, the Village was destroyed by fire before it reopened.

SURF THEATRE, OCEAN CITY, 2004. This shows the stage end of the former Surf Theatre at Twelfth Street and the boardwalk. When opened by Hunt Theatres in 1927, it was named the Showboat. Renamed the Surf after a storm tore Showboat off the marquee, it was never successful as an independently owned house in this city. Finally sold to the Shrivers, it closed and became the Surf Mall.

SEASIDE THEATRE, SOMERS POINT, 1942. Just over the Ninth Street bridge from Ocean City is the town of Somers Point. At Bay and Higbee Avenues was the 380-seat Seaside Theatre, also run by the Shriver chain of Ocean City. It is still standing, named the Gateway Playhouse, and is home to a live regional theater company.

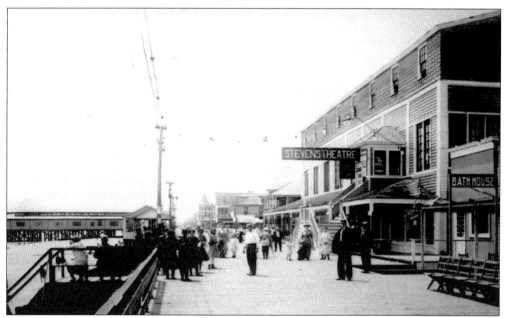

STEVENS THEATRE, SEA ISLE CITY, 1910. Sea Isle City's first theater was located in the Excursion House on the boardwalk. The Excursion House dates to 1882 and housed baths, a skating rink, an observation level, and this theater. The Stevens was used for many town events, including the early showings of motion pictures. The pier on the ocean side of the boardwalk was known as the Cini Ocean Pier.

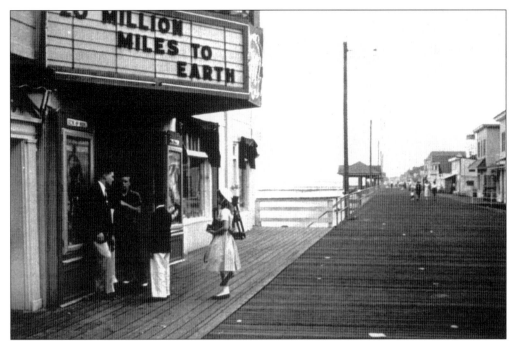

MADELINE THEATRE, SEA ISLE CITY, 1957. Located at the front of the Cini Ocean Pier, at Forty-second Street and the boardwalk, the Madeline was a 625-seat theater, dating to the silent film era. Run by the Braca family, the Madeline survived the major coastal storm of 1942 but was lost forever in the storm of October 1962. (Courtesy Sea Isle City Historical Society.)

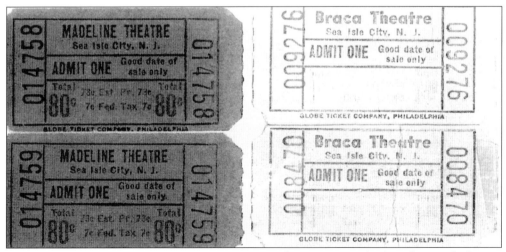

MADELINE AND BRACA THEATRE TICKETS, 1950S. Shown are actual tickets from each theater. It is interesting to note that the admission price was 80¢ at this time! The Braca, which continued to run into the 1960s, eventually reached a $2.50 admission. (Courtesy Sea Isle City Historical Society.)

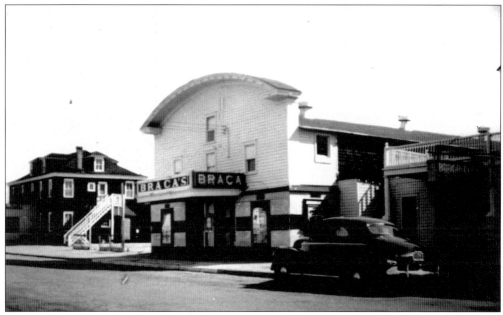

BRACA THEATRE, SEA ISLE CITY, 1941. The Braca Theatre building still stands at JFK Boulevard and the Promenade. It operated as a 300-seat summer house through the 1960s, when it closed, becoming retail space. The Promenade, which replaced the destroyed boardwalk, now runs through the area occupied by the house on the left of the theater, and the Braca Café continues to operate in the building on the right.

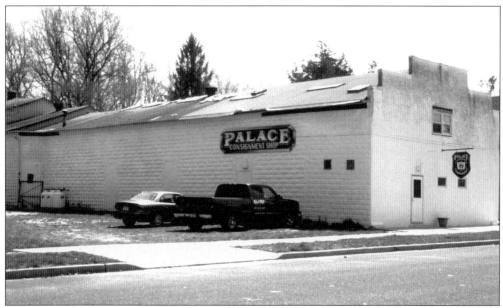

LYRIC THEATRE BUILDING, WOODBINE, 2004. Joseph Katz opened the Lyric Theatre on Adams Avenue in the early 1920s, featuring a Wurlitzer pipe organ. Jack Greenberg, who ran the Park Theatre in Stone Harbor, later built the 496-seat Capital Theatre on the same block, equipping it for sound. This forced the closing of the Lyric. It became the Palace Skating Rink and is still standing and used as an antiques shop.

AVALON THEATRE, AVALON, 1950. Built in the early 1900s, this 585-seat theater was in a city-owned pier at Twentieth Street and the boardwalk that also housed stores and an arcade. The Avalon had a fully equipped stage for vaudeville and was leased and operated for many years by the Hunt chain. The pier was so badly damaged by hurricane Gloria in September 1985 that it was condemned and torn down.

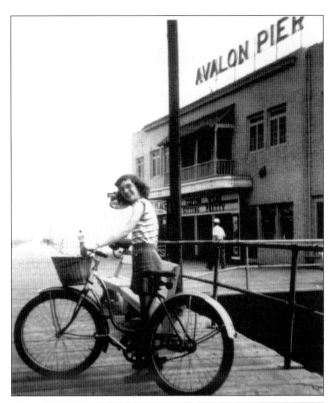

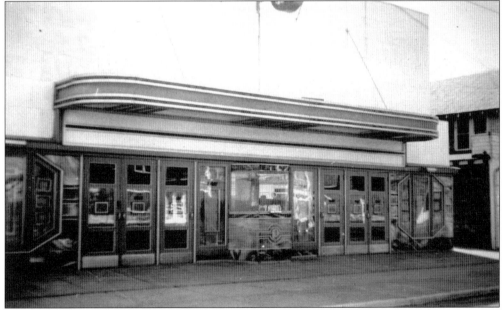

PARK THEATRE, STONE HARBOR, 1941. Jack Greenberg built the Parkway Theatre on Ninety-sixth Street in 1922. Prior to its opening, Stone Harbor residents saw their movies at the Municipal Pier. In 1936, Greenburg remodeled the 460-seat theater and renamed it the Park Theatre. It was eventually sold to the Hunt chain, and it closed in the late 1980s. The building is presently used for retail stores.

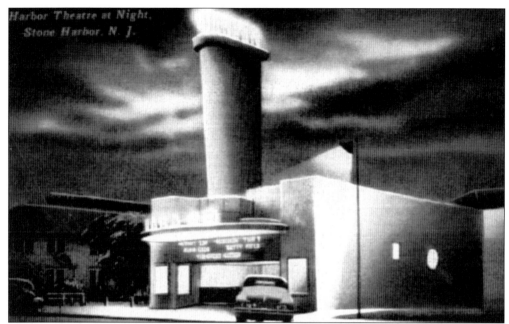

HARBOR THEATRE, STONE HARBOR, 1949. This 800-seat house was built by Jack Greenberg on Ninety-sixth Street, a few doors down from the Park. It provided Stone Harbor with a new modern theater that was to run year-round. Along with the Park, it was sold to Hunt Theatres and, in 1986, to the Frank chain. It was first twinned, then converted to a five-plex. The Harbor Theatre is still running.

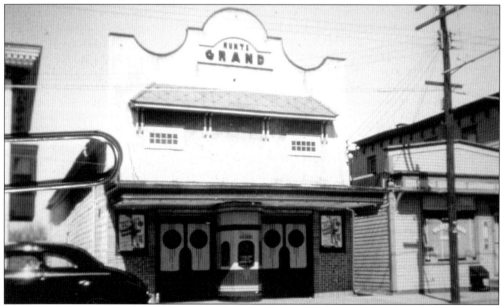

GRAND THEATRE, CAPE MAY COURT HOUSE, 1941. On the mainland, just east of Stone Harbor, is Cape May Court House, the county seat. William C. Hunt opened the 250-seat Grand Theatre here on Mechanic Street in 1915. It closed in the late 1950s and was razed, along with many other buildings, to permit construction of the new Cape May County Seat campus. (Courtesy Gary Feldman collection.)

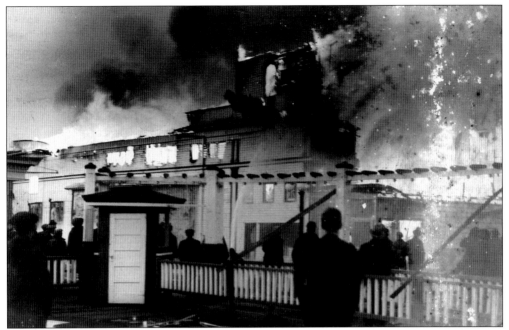

ORIGINAL CASINO THEATRE FIRE, WILDWOOD, 1939. Hunt's original Casino Theatre, at Atlantic and Cedar Avenues, opened in 1923 with a Robert-Morton pipe organ to accompany silent films. This original wooden structure burned to the ground on April 13, 1939. (Courtesy Harold Sherwood.)

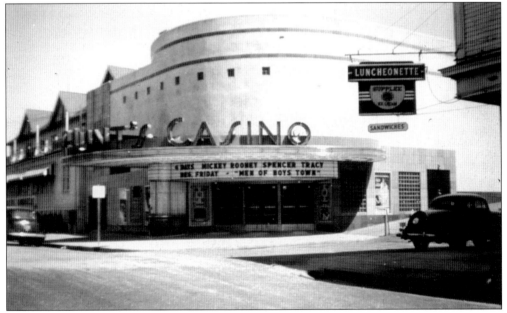

CASINO THEATRE, WILDWOOD, 1941. Hunt Theatres built this beautiful art deco house to replace the first Casino Theatre lost to fire in 1939. A year-round operation, this Wildwood landmark had 1,000 seats on the main level and an additional 200 seats in the balcony. It continued to serve residents and visitors alike until it closed in the 1970s. The Casino Theatre was razed in the spring of 1999.

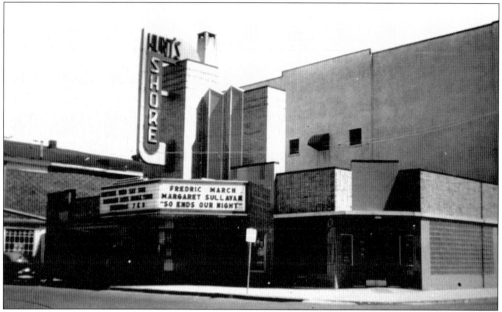

SHORE THEATRE, WILDWOOD, 1941. Hunt's Shore Theatre, designed by Thalheimer and Weitz, was located at 3400 Atlantic Avenue and designed for year-round operation. Before it was twinned in the 1970s, it had 1,040 seats on the main floor and 467 in the balcony. The Shore closed by the end of the 1970s, and while still standing in 2005, it was scheduled to be demolished along with the nearby Blaker Theater.

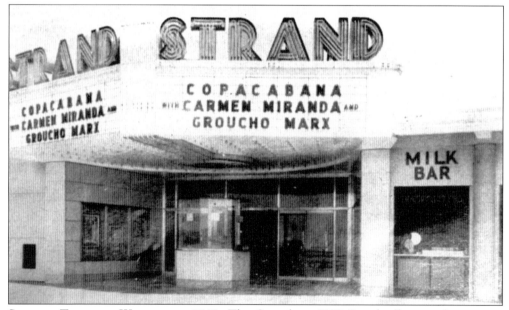

STRAND THEATRE, WILDWOOD, 1947. The Strand, at 3100 Boardwalk, was the premier boardwalk theater for the Hunt chain. Built in 1946, it replaced the original Strand that was destroyed by fire in 1944. Both Strand Theatres were designed by architect William H. Lee. The 1946 house was built of steel, cinder-block, and concrete, an attempt at fireproof construction. The new house featured 1,600 seats, the original had just 649.

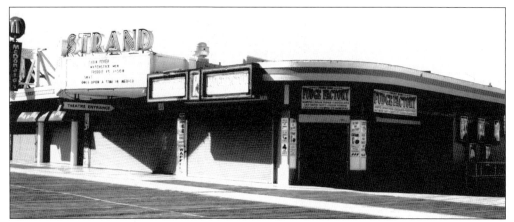

STRAND THEATRE, WILDWOOD, 2005. Now independently owned, the theater has been converted to a five-screen multiplex for summer operation only. Note that the beautiful entrance is gone, with the boardwalk frontage being used for various retail spaces, which can command high rental fees.

SEA THEATRE, WILDWOOD, 2003. The Sea Theatre, at 4005 Pacific Avenue, is owned and operated by Taras and Alexandra Penkalskyj. Opened in 2003, it is a cozy 70-seat, art deco screening room, located in a building that might have been a nickelodeon in the early 1900s. The Sea Theatre is open all year, specializing in foreign and "art" film.

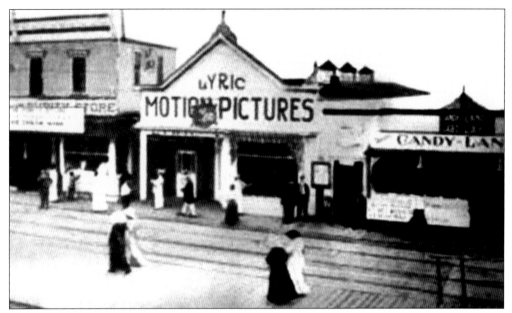

LYRIC THEATRE, CAPE MAY, 1915. The Lyric, on the west side of the boardwalk, was one of three original Cape May silent venues. The Cox Theatre and the Auditorium on the city-owned pier completed the trio. The Liberty Theatre, at 509 Washington Street, opened in 1920, with 750 seats and a pipe organ, and flourished until being razed for the Washington Street Mall; the others closed as silent houses.

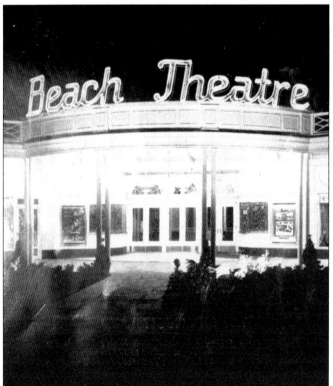

BEACH THEATRE, CAPE MAY, 1950. The opening of Hunt's new Beach Theatre, at 711 Beach Avenue, eventually led to the closing of the city-owned, Hunt leased Auditorium on the pier across the street. Residents and visitors alike were pleased to have a more modern year-round theater. It was converted to a multiplex in the 1980s and continues to operate successfully today.

Four

GLOUCESTER, SALEM, CUMBERLAND, AND ATLANTIC COUNTIES

Gloucester, Salem, Cumberland, and Atlantic counties are, and have always been, primarily agricultural areas producing some of New Jersey's most important crops—blueberries, cranberries, tomatoes, sweet potatoes, apples, and peaches. Several industries also sprang up and thrived around the region's farm economy. Canning companies like Del Monte and Heinz, glassmaking factories, and even one of the world's largest farm freezing operations, Sea Brook Farms, can be found here.

With the exception of some of the towns of Gloucester County, which were closer to Philadelphia and Camden and more densely populated, the more rural towns in these counties had smaller populations and, thus, fewer movie theaters, mostly independently owned. The larger cities, such as Bridgeton, Vineland, Pitman, and Salem, did have some grand movie palaces, which were mostly owned or leased by the movie studios. Hammonton, the "Blueberry Capital of the World," had two important theaters, Bridgeton four, Salem three, and Vineland three. Millville and Pitman are each home to historic theaters that are still intact today and either running or undergoing renovation.

The area was also home to two important pioneer exhibitors, Eugene Mori and Samuel Frank. Eugene Mori built the Landis Theatre in Vineland, which played an important role in the Supreme Court case that ended the studio monopolies. He went on to build the Garden State Race Track and the Cherry Hill Inn in Delaware Township. Delaware Township would later be renamed Cherry Hill. Samuel Frank built a successful chain of theaters that is still running and being expanded by his family today.

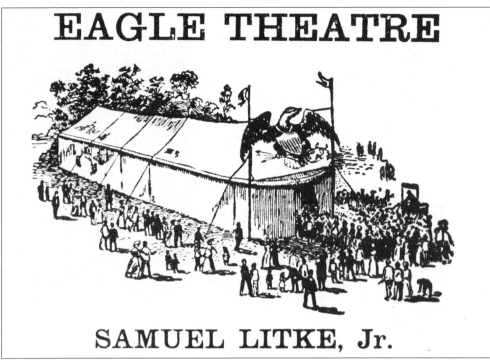

EAGLE THEATRE

SAMUEL LITKE, Jr.

EAGLE THEATRE, HAMMONTON, 1912. Samuel M. Litke Jr. was Hammonton's first film exhibitor, using the O'Donnell building at Bellevue Avenue and Egg Harbor Road. The building was too warm for large crowds in the summer, so in 1912, he put up a tent on Vine Street near Second Avenue and called it the Eagle Theatre. In 1914, he built a 350-seat permanent structure on the site. (Courtesy Hammonton Historical Society.)

PALACE THEATRE, HAMMONTON, 1918. Litke's success led another local entrepreneur, James Palmer, to open the 240-seat Palace Theatre at 206 Bellevue Avenue on August 31, 1912. Samuel Frank, a Hammonton resident, and his partner Jack Flynn bought the Eagle and the Palace in 1923. The Eagle closed in 1927, but the Palace continued to run until it was converted to retail space in 1951. (Courtesy Hammonton Historical Society.)

RIVOLI THEATRE, HAMMONTON, 1954. Located at 253 Bellevue Avenue, this 1,200-seat theater opened on December 26, 1927, with *Arabian Knights* starring William Boyd and Mary Astor. Originally named the Third Avenue Playhouse, it was designed by architects Magziner, Harris and Eberhard in a blend of Moorish, Spanish, and Italian styles. A Sam Frank theater, it closed in 1961, and the building was converted to office space. (Courtesy Hammonton Historical Society.)

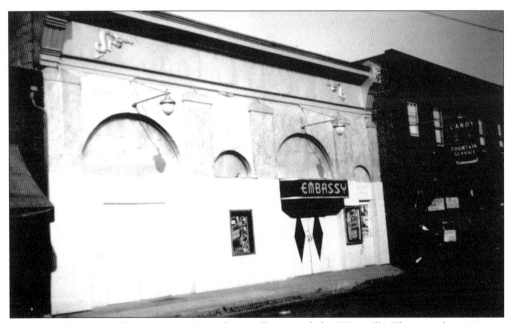

EMBASSY THEATRE, WESTVILLE, 1941. Originally named the Westville Theatre, this 444-seat house was built and opened in 1923 by William L. Lowe. It featured a Marr and Coulton pipe organ. Although Lowe sold the theater in 1938, it continued to operate as a neighborhood house until falling victim to competition from television. The Embassy closed in the mid-1950s and was razed several years later.

THE OPERA HOUSE, WOODBURY, 2004. The G. G. Green Building, at 108 South Broad Street, was built in 1880 by Col. George G. Green to provide the county seat with entertainment and retail space. By 1919, the Opera House in the building was being used primarily for motion pictures. It was sold to the Woodbury Amusement Company, redesigned by architects Hoffman and Henon, and became the 1,100-seat Rialto Theatre.

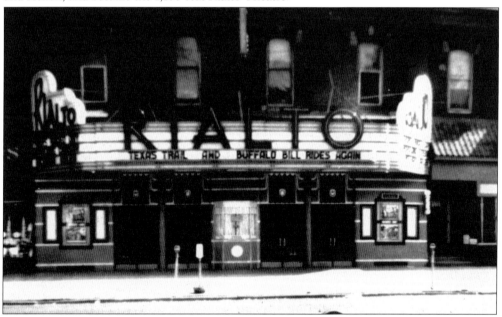

RIALTO THEATRE, WOODBURY, 1937. The Rialto was sold to the Stanley Company of America in 1926. In 1935, the Stanley Company installed the marquee seen here, added air-conditioning, and redid the interior to give it an art deco appearance. The exterior Romanesque style of the building remained unchanged. The G. G. Green Building is listed on the New Jersey Register of Historic Places.

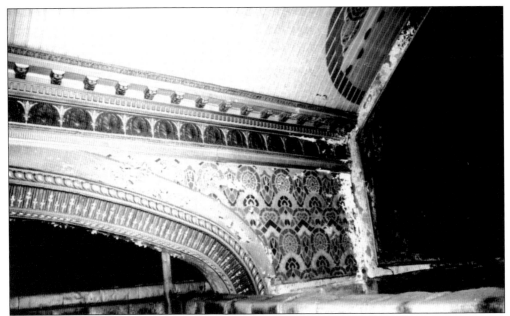

RIALTO THEATRE PROSCENIUM, WOODBURY, 2004. While the Rialto closed in 1955 due to competition from the newer Wood Theatre across the street and television, much of it remains. The street level entrance was eliminated when the space was converted for retail use, but the top two floors remain almost intact. This photograph shows a portion of the stage proscenium and painted ceiling. (Courtesy Westfield Associates.)

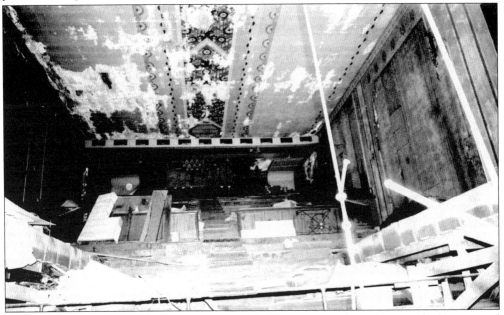

RIALTO THEATRE BALCONY, WOODBURY, 2004. This is a view from the stage looking toward the rear of the 480-seat balcony, with the balcony railing seen in the foreground. The balcony covered approximately two-thirds of the 646-seat orchestra level. As of 2005, the building was scheduled for restoration, with plans to use it as a performing arts venue, keeping alive the intentions of Col. George G. Green. (Courtesy Westfield Associates.)

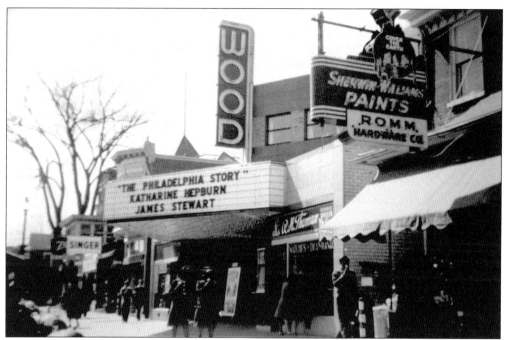

WOOD THEATRE, WOODBURY, 1941. Located on Broad Street, across from the Rialto Theatre, the Wood opened in 1940, with 817 seats on the main level and an additional 239 in the balcony. To prepare for CinemaScope pictures, the management, Atlantic Theatres, installed a 45-foot-wide curved screen with a wall-to-wall curtain in front of the original proscenium. The theater closed and was razed in the 1970s.

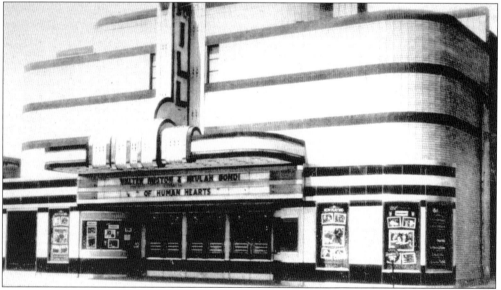

HILL THEATRE, PAULSBORO, 1938. Located at 35 West Broad Street, this Hill Theatre, built by Alfred W. Hill, opened in 1935 with 950 seats. Paulsboro's first theater, the 585-seat Bailey, opened in 1915, was purchased by Hill in 1918 and promptly renamed the Hill. After building his newer and larger house, Hill renamed his original building the Boro Theatre and ran both for many years.

72

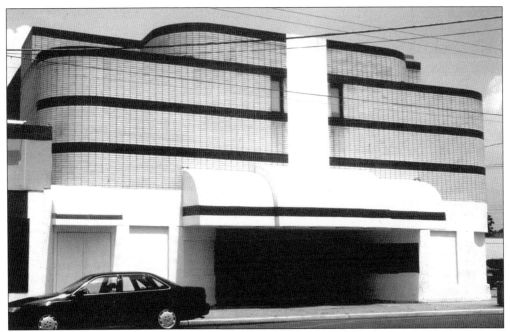

HILL THEATRE STUDIO, PAULSBORO, 2004. This beautifully preserved art deco building is now used as a film and television production soundstage. Owned and operated by John J. Burzichelli, Angelo "Sonny" Gellura, and Arthur Lassin, its location, just off interstate Route 295, makes it very convenient to Philadelphia and New York.

HILL THEATRE STUDIO, PAULSBORO, 2004. While the auditorium has been converted to a production soundstage, the lobby areas of the Hill Theatre remain as they were. Here one of the art deco lighting fixtures in the main lobby area can be seen, as well as some of the extensive wood treatments. This space is presently used for meetings and conferences.

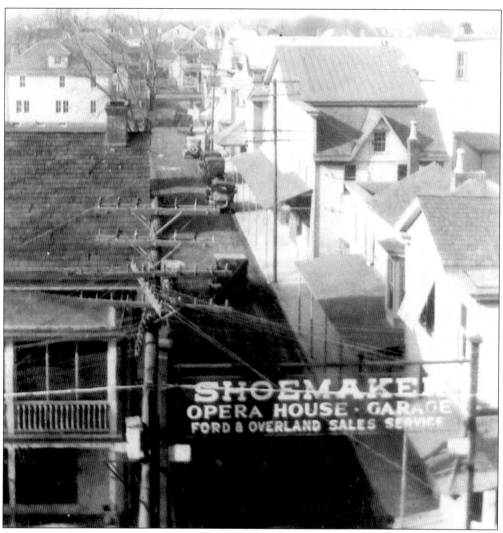

SHOEMAKER'S OPERA HOUSE, SWEDESBORO, 1915. Movies arrived in Swedesboro in 1909 as an added attraction in the skating rink on Kings Highway. In 1910, they moved to a building on Allen Street. After completion of Shoemaker's 400-seat opera house, at 23 Allen Street, in 1915, it became the home of movies, opera, and vaudeville. The original building became Shoemaker's Garage. Later the opera house was renamed the Embassy. The Embassy closed in July 1950, and the space was incorporated with the garage business. The entire complex was torn down in June 1961. (Courtesy William Frederick Sr.)

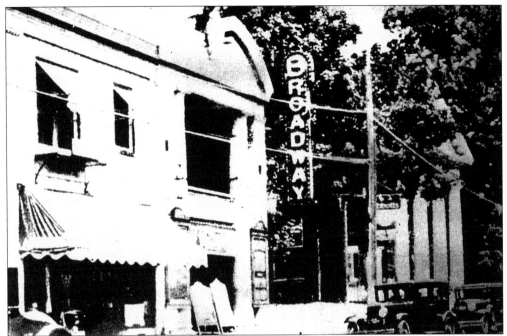

BROADWAY THEATRE, PITMAN, 1926. The Broadway, Pitman's second theater, opened on May 29, 1926, at 43 South Broadway. It joined Hunt's 1913 Park Theatre, on the corner of Pitman and West Jersey Avenues, in providing the borough with entertainment. This photograph shows the original theater façade with the vertical Broadway sign. Take note of the opening above the entryway, allowing light into the box office area.

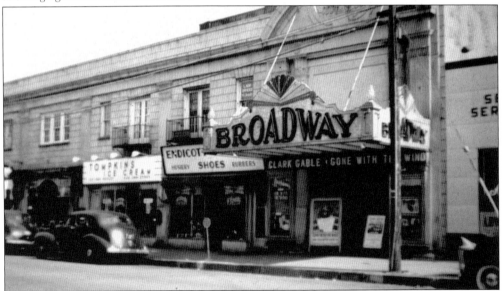

BROADWAY THEATRE, PITMAN, 1939. This photograph shows the present neon marquee with the opening above the entryway sealed. The original managers, Howard Wilkins and his son Ralph, partnered with William Lacey to purchase the 1,100-seat theater during its first year of operation. Ralph Wilkins ran the theater until 1971, when he sold it to Clayton "Duffy" Platt, whose name would become synonymous with the Broadway for over 30 years.

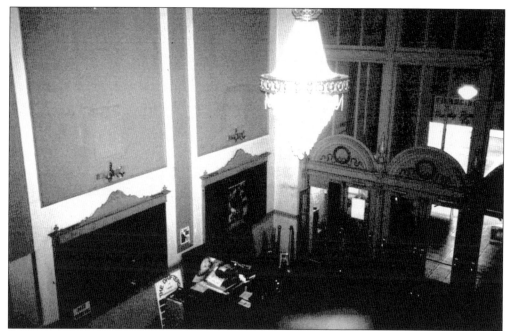

BROADWAY THEATRE LOBBY, PITMAN, 2001. This view shows one of the original crystal chandeliers hanging over the main lobby, the main entrance from the interior, and some original poster display cases uncovered in the restoration of the Broadway. The photograph was taken from the balcony stairway.

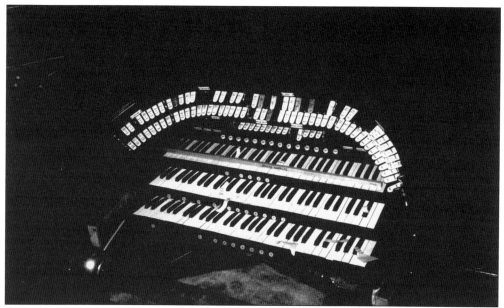

BROADWAY THEATRE'S KIMBALL ORGAN, PITMAN, 2001. Duffy Platt made many attempts to revive stage shows in the 1970s and 1980s with live appearances by important country-and-western acts. The Broadway received national attention when HBO's *Here It Is, Burlesque* won the 1980 Cable Ace Award after being taped there. In 1999, Platt sold the Broadway to Daniel Munyan and Charles Kern. They began a major restoration project that, as of 2005, was still under way.

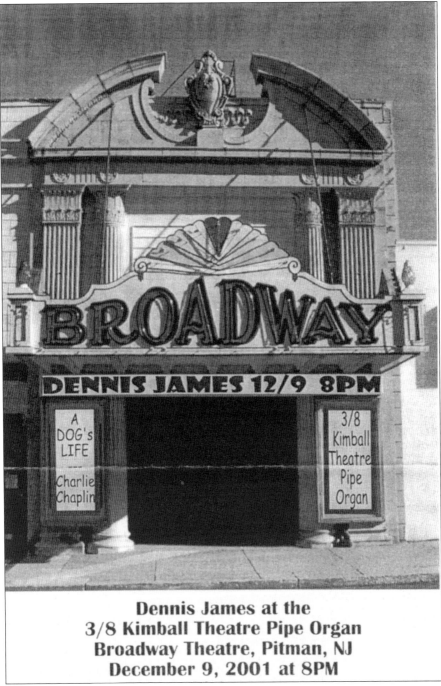

**Dennis James at the
3/8 Kimball Theatre Pipe Organ
Broadway Theatre, Pitman, NJ
December 9, 2001 at 8PM**

BROADWAY THEATRE ANNOUNCEMENT OF RESTORED ORGAN DEBUT, PITMAN, 2001. This herald-style announcement is for the public debut of the Southern Jersey Theatre Organ Society's restoration of the Broadway's Kimball organ. Dennis James, a Cherry Hill native, was resident organist for the Ohio Theatre in Columbus and Disney's El Capitan in Los Angeles. He is world renowned for his work on the glass armonica. Theater owner Dan Munyan continues to feature the Kimball organ every week; it is not to be missed!

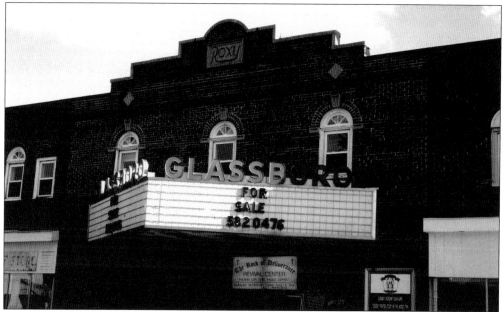

GLASSBORO/ROXY THEATRE, GLASSBORO, 2002. The Roxy Theatre opened in 1928, joining Glassboro's 1922 Palace Theatre. The Roxy, built for motion pictures and vaudeville, had 750 seats, a Page organ, and a large stage. It was taken over by Duffy Platt and renamed the Glassboro Theatre. It closed in the 1970s and is still standing. Being in a college town, it seems to be a natural choice for restoration as a concert and film venue.

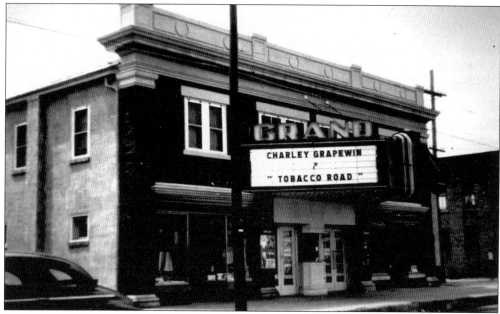

GRAND THEATRE, WILLIAMSTOWN, 1941. This 450-seat theater, built by James Lanzalotti, opened in 1924 with *Barbara Fritchie*, accompanied on the piano by Amy Huber, a local resident. The Grand was remodeled and received a new marquee in 1940. It was sold to a church congregation in the 1970s and, in 2004, purchased by Dale Nelson with plans for restoration as a theater once again.

GRAND THEATRE, VINELAND, 1941. Built by Handle and Rovner in 1921, the Grand had 990 seats and featured a Wurlitzer pipe organ. Both the Grand and the older 600-seat Globe were sold to Stanley-Warner in 1934. Construction of the new Landis Theatre led Stanley-Warner to remodel its Grand Theatre, which reopened on March 11, 1937. The Globe and, later, the Grand were closed and razed by the 1960s.

LANDIS THEATRE, VINELAND, 1941. Because the Globe and Grand Theatres were in such poor physical condition, local businessman Eugene Mori and his brothers decided to build a new theater. Famous architect William H. Lee designed this 1,183-seat house in art deco style. It opened on March 12, 1937, was twinned in the 1970s, and closed in 1987. As of 2005, it was still standing with plans for restoration.

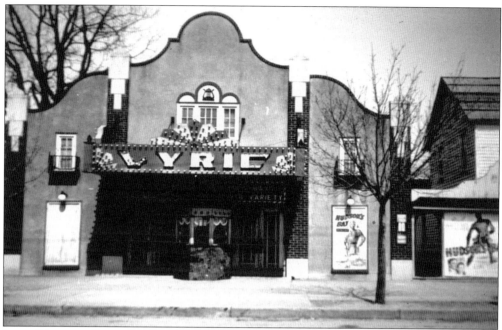

LYRIC THEATRE, LANDISVILLE, 1941. The 699-seat Lyric, located between Vineland and Buena (site of the Buena Theatre), was originally named the Landisville Theatre. It was a typical neighborhood house that closed in the late 1950s as the number of television receivers continued to climb, forever changing the habits of its former audience. (Courtesy Gary Feldman collection.)

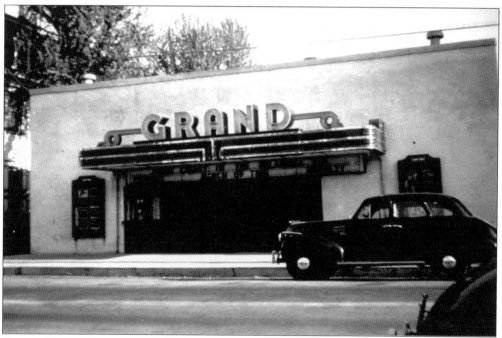

GRAND THEATRE, WOODSTOWN, 1941. The Grand Theatre, run by Harold Thorp, was located on East Harding Highway. It was a lovely neighborhood theater with 500 seats. It came under Milgram management in the late 1960s and was closed and torn down in the 1970s.

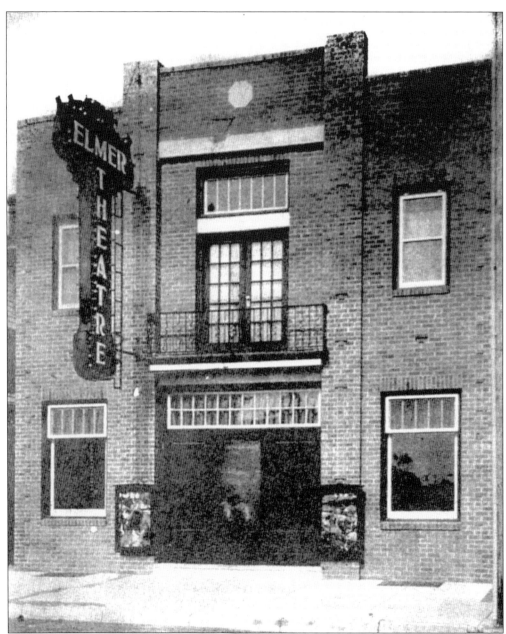

ELMER THEATRE, ELMER, 1930. This tiny jewel was built in 1927 by Elmer's mayor, Samuel H. Wright. Totally fireproof, it opened on Labor Day 1927, with 180 seats on the main floor, 110 seats in the balcony, and a Wurlitzer pipe organ. Wright ran the theater through 1946, when it was sold and renamed the Star. The house closed in the 1950s and was razed in the 1960s. (Courtesy Peggy Corson.)

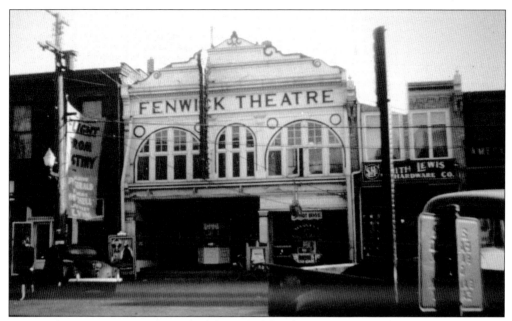

FENWICK THEATRE, SALEM, 1941. The Fenwick Theatre was named after John Fenwick, founder of Salem. It had 522 seats on the orchestra level with an additional 200 in the balcony. In addition to the Fenwick, Salem was home to two other theaters, the Palace and Hunt's. Hunt's Theatre and the Fenwick were gone by the late 1950s, but the Palace remained in operation until 1963.

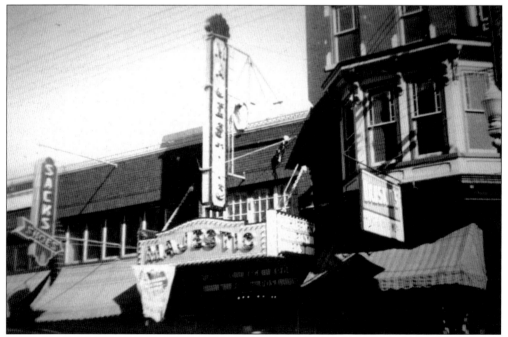

MAJESTIC THEATRE, BRIDGETON, 1941. The Majestic was the smallest of Bridgeton's four theaters. It had 394 seats on the main level and an additional 128 in the balcony. It closed in the late 1950s, a victim of both television and the area's economic decline.

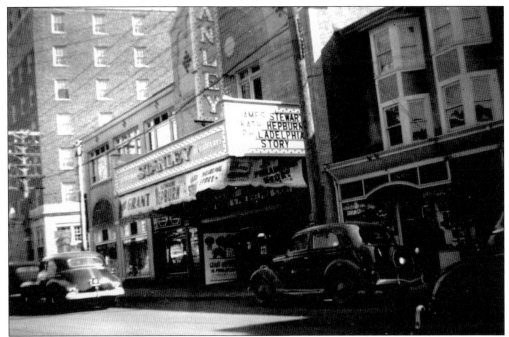

STANLEY THEATRE, BRIDGETON, 1941. The Stanley, built in 1928, lasted but 20 years. The theater, with 1,555 seats and a Kimball pipe organ, fell into disrepair and was razed in 1948. The building pictured to the left of the theater was the Cumberland Hotel, also now gone.

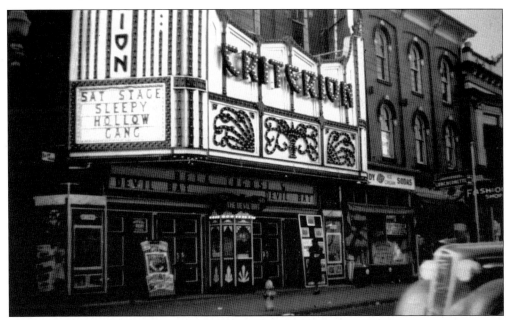

CRITERION THEATRE, BRIDGETON, 1941. The beautiful Criterion Theatre was home to movies, vaudeville, and radio broadcasts through the early 1940s. The house had 605 seats on the orchestra level, 307 in a balcony, and even had a few loge seats. After the closing of the Owens-Corning Glass plant in 1984, Bridgeton's economy declined rapidly and so did its downtown, its department stores, and its picture palaces.

LAUREL THEATRE, BRIDGETON, 2004. The last theater built in the city, the Laurel Theatre, arrived in 1950. Operated by Atlantic Theatres, it was able to survive into the 1970s by showing Spanish language films for the largely migrant farming population that had moved into the area. By 1979, it had physically deteriorated, closed, and had its name removed from the marquee. The building, as of 2005, was scheduled to be torn down.

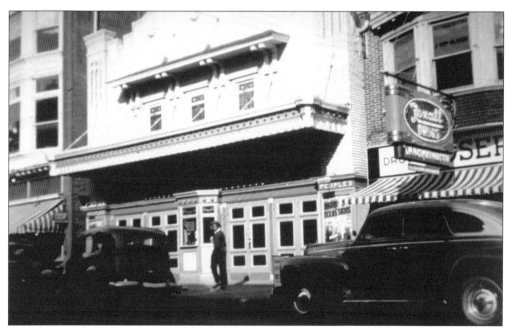

PEOPLES THEATRE, MILLVILLE, 1941. Built by Handle and Rovner at 113 West High Street in 1921, the Peoples Theatre had 748 seats on one level and featured a Moller pipe organ at opening. While it was Millville's second theater and built especially to showcase movies, it was the first forced to close from the competition of television in the 1950s. (Courtesy Gary Feldman collection.)

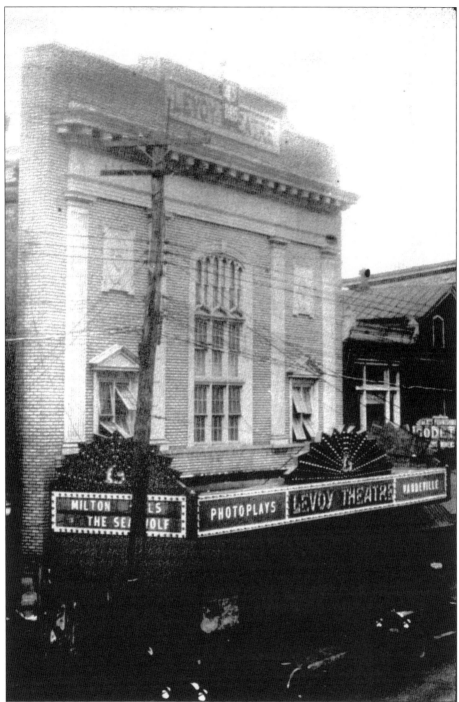

LEVOY THEATRE, MILLVILLE, 1930. Located at 138 High Street, the Levoy first opened its doors in 1912. In 1927, Handle and Rovner completely remodeled the 1,385-seat theater and had a Lenoir pipe organ installed. Stanley-Warner purchased the Levoy in 1934 and, later, Milgram Theatres ran it until closing in the 1970s. In 1995, the Levoy Theatre Preservation Society was organized with plans for restoration as a multifunction arts venue.

COLONIAL THEATRE, PORT NORRIS, 1950. Located on Main Street, this 380-seat theater was built by Jacob Rosenfeld in 1948. Following many years of work as a projectionist, owning the Colonial was Rosenfeld's dream come true. This photograph shows the screen end of the attractively decorated auditorium in Port Norris, at this time a sizeable seafood producing town near the Maurice River.

COLONIAL THEATRE, PORT NORRIS, 1950. The postwar years were "boom" years for movie attendance, and initially the Colonial's seats were full. However, Jacob and his wife, Mildred, were soon to feel the competition of "free" entertainment from television, and after only 10 years of operation, the Colonial closed and was razed in 1958. This view is the rear of the auditorium, with the popular candy vending machine seen at the left.

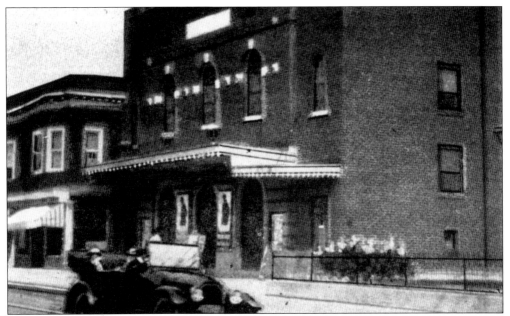

BROAD THEATRE, PENNS GROVE, 1924. This photograph is from a postcard showing the original marquee and façade of the Broad Theatre, as it looked on Broad Street, in the early 1920s. Penns Grove is located on the Delaware River, opposite Wilmington, Delaware. There were several daily ferries from Wilmington, as well as the Wilson Line steamers from Philadelphia, bringing visitors to Riverview Beach, a popular amusement park nearby. (Courtesy Paul W. Schopp collection.)

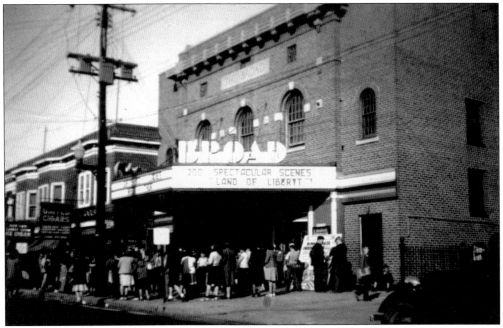

BROAD THEATRE, PENNS GROVE, 1941. The Broad, built as a vaudeville and picture house, had 673 seats on the main level and 299 in the balcony. In the late 1930s, it was joined by the 600-seat Grove Theatre; both were run by Atlantic Theatres. The Broad closed in the late 1950s, and the Grove continued to operate throughout the 1960s. (Courtesy Gary Feldman collection.)

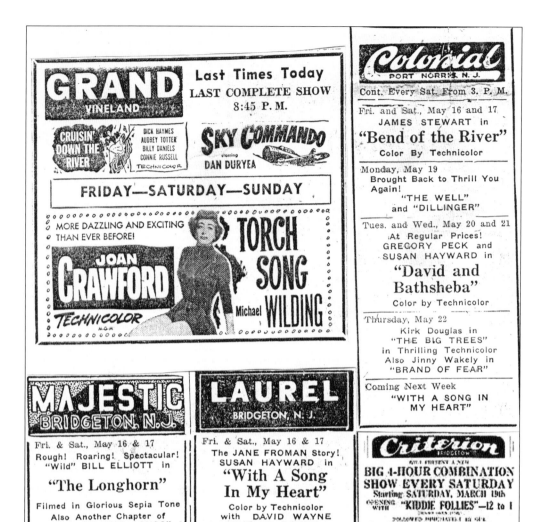

CUMBERLAND COUNTY THEATER ADVERTISEMENTS, 1938–1950S. Newspaper display advertising, even for local theaters, was common until the 1970s. Of special interest in this grouping is the Criterion's, in Bridgeton, advertisement featuring a full-length feature and stage show at 25¢ admission for adults and 10¢ for children! Of course, it was in 1938.

Five

TECHNOLOGY

During the late 1800s, inventors throughout the world experimented with ways to make and project motion pictures. Success came to several pioneers at the same time, particularly after Hannibal W. Goodman invented transparent, flexible film in 1884, and George Eastman manufactured it in 1889. The film was first used in Kinetoscope boxes and, by 1895, in devices that projected movies on a screen. Experimentation with sound soon followed, beginning with Thomas Edison's attempt in 1914 to connect his phonograph and camera, through synchronized Vitaphone discs, and the development of optical (photographic) sound on film. Eventually, after much experimentation, the industry standard became 35-millimeter film with an optical sound track and an aspect ratio of 4:3.

When the new medium of television grew in popularity in the 1950s, the "free" competition affected the box office. The studios and the theater owners turned to old techniques to lure people away from the "tube" and back into the theaters.

In 1927, French film director Able Gance used a multiple projector, wide screen process for the finale of his epic film *Napoleon*. In 1952, this projection technique, renamed Cinerama, was revived with the added attraction of stereophonic sound. It was an instant success, and while short-lived because it was expensive to produce and exhibit, it changed the shape of theater movie screens forever.

Since few theaters could physically or economically handle Cinerama, other systems based on early technology were introduced to attract audiences. The first was 3-D, a process dating back to the 1800s, when people peered through stereoscopes to see three-dimensional scenes. It was initially successful, but patrons hated wearing the polarized glasses. The "modern miracle you see without glasses" was next, a revival of a wide screen process developed in the 1920s using one camera, one projector, and Henri Chrieten's anamorphic lens. It was to be called CinemaScope. Finally the 65-millimeter cameras used in the 1930s would be unpacked for special blockbusters like *Oklahoma, The Sound of Music*, and *Star Wars*. In order to add six channels of stereophonic sound for these special films, the prints released to theaters were actually 70 millimeters wide.

From silent productions to Dolby Stereo, digital photography, and, soon, digital projection, the development of movie technology has always been fascinating and is constantly evolving.

Power's "6B" Improved
With Type "E" Lamp and Lamphouse

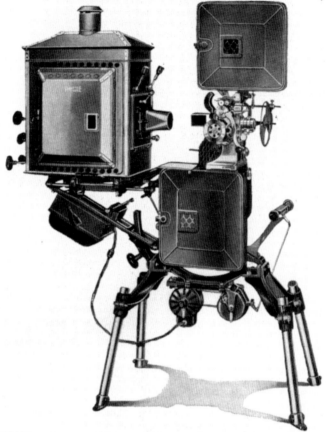

PRACTICAL operation in many of America's leading theatres has conclusively demonstrated the reliability and general superiority of our newest and finest model, Power's "6B" Improved Projector.

Workmanship and materials are always the best in every Power's Mechanism and there is no difference in design or construction. "6B" Improved with Type "E" Lamp and Lamphouse, however, has special features which add to the projectionist's control of the machine and materially assist in securing better projection. The Improved Model costs comparatively little more than the Regular Model and the additional advantages more than justify the difference in price. The special features furnished with Power's "6B" Improved with Type "E" Lamp and Lamphouse would cost considerably more if purchased separately.

POWERS 6B PROJECTOR, 1925. The Nicholas Powers Company was one of the two major manufacturers of theatrical projection equipment. This photograph shows its 6B projector, with the standard Powers "square" upper and lower film magazines. These magazines enclosed the reels of film, which at this time were nitrate based and extremely flammable. The light source was carbon arc, brighter and whiter than any other source of illumination of the period. Powers projectors were installed in most South Jersey projection rooms.

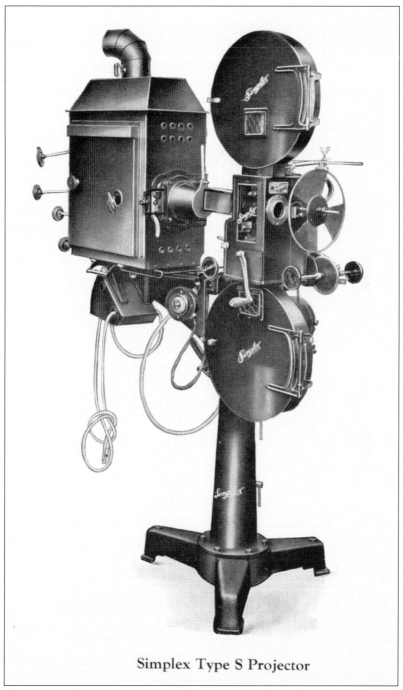

Simplex Type S Projector

SIMPLEX STANDARD PROJECTOR, 1926. Simplex was the other major manufacturer of professional projectors and continues to manufacture them to this day. Both the Powers, on the opposite page, and this machine were made for silent film. Take special note of the crank on both machines, as in the beginning, movies were hand cranked at the speed of 60 feet per minute. The Simplex Standard, now motor driven, was still in use at the Crescent Theatre in Haddon Township as late as 1958, of course, with the addition of an RCA sound attachment.

SOUND ON FILM
OPERATION
and
MAINTENANCE
MANUAL

For Projectionists

No. 2002

Issued by Service Engineering Department of

PACENT REPRODUCER CORP.

Film Center Bldg. New York

Tel. Chickering 7948-49-50-51-52

PACENT SOUND ON FILM MANUAL, 1930. From the late 1920s into the early 1930s, two competing sound systems were used. One was optical, photographic sound on the same film as the image, and the second was synchronized discs, made popular by Warner Brothers' release of *The Jazz Singer* in Vitaphone. This manual explained the operation of the sound on film attachment, installed below the projector head. Optical or photographic sound would become the industry standard and is the basis of today's sound tracks.

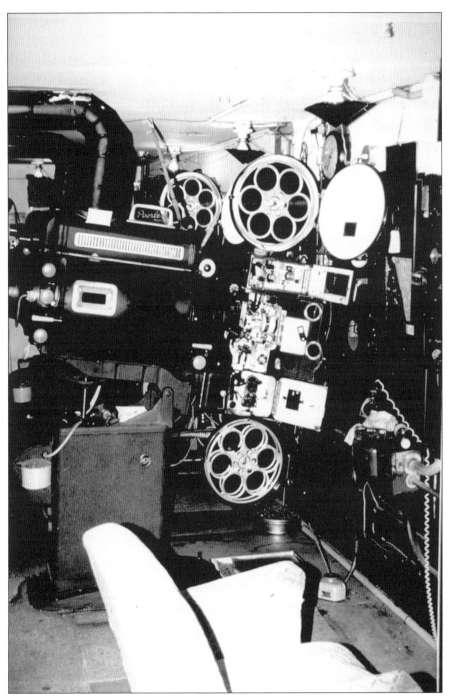

WALT WHITMAN THEATRE PROJECTION ROOM, 1960. This photograph shows the standard two-projector installation found in most theaters. The film magazines hold standard 2,000-foot reels that run approximately 20 minutes at sound speed. One can see the optical soundhead or attachment, located between the lower magazine and the projector head. Between the upper film magazine and the projection head is the stereophonic soundhead, developed for CinemaScope films and installed in the 1950s.

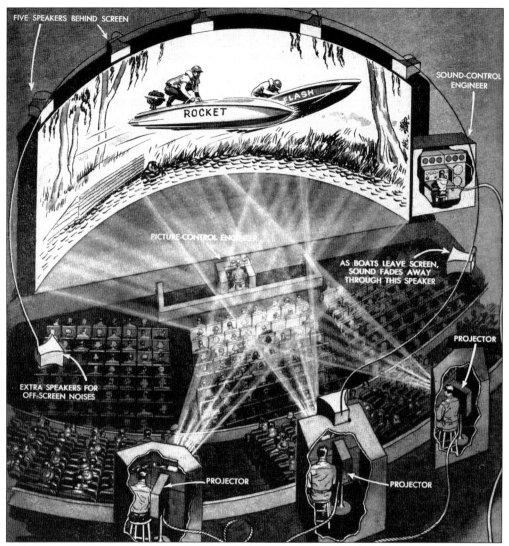

CINERAMA DIAGRAM, 1952. Postwar sales of television sets prompted audiences to stay home and watch the "tube." The movie industry turned to technology that television could not replicate. First up was Cinerama, a three-camera, three-projector system using a massive curved screen to envelop the audience in the sights and sounds of the image. Being expensive to produce, and expensive to exhibit, it had limited theater installations. South Jersey patrons could only see it at the Boyd Theatre in Philadelphia.

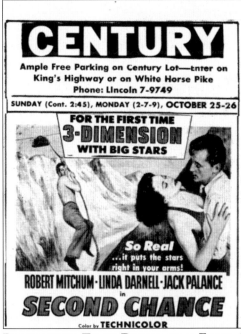

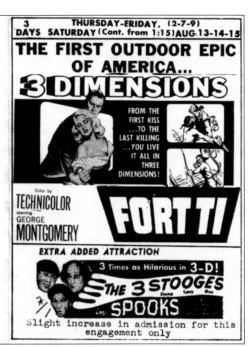

PROGRAM FOR THREE-DIMENSIONAL FILMS, 1953. Something was needed to bring patrons back to the neighborhood houses. The studios and exhibitors decided it was time to bring back 3-D movies, briefly popular in the 1930s. By photographing separate left and right images, running two projectors simultaneously to project them, and requiring patrons to wear polarized glasses, it was possible to give audiences three-dimensional thrills they could not see on television.

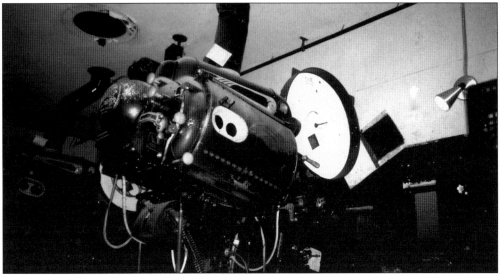

LEVOY THEATRE, MILLVILLE, 1953. As 3-D projection required running both projectors simultaneously, larger reels of film (and magazines on the machines) were required. One can see the special 5,000-foot magazines, for the larger reels, installed in this photograph. All 3-D films of this period were less than 90 minutes to permit a presentation with only one "reel change" intermission. This limitation, and audience dislike of glasses, led to a rapid demise of three-dimensional pictures.

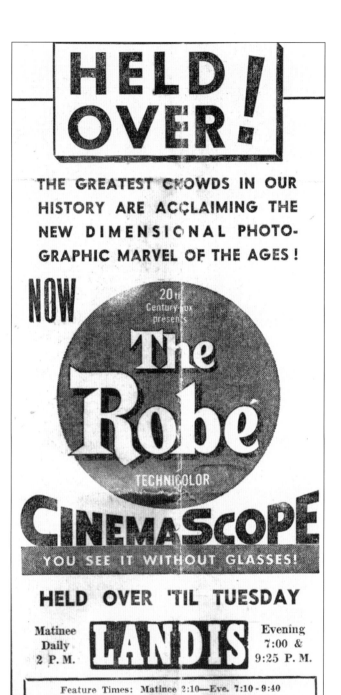

Landis Theatre CinemaScope Advertisement, Vineland, 1954. In an attempt to have the look of Cinerama with only one projector and standard 35-millimeter film, 20th Century Fox studio adopted a technique using an anamorphic lens and named it CinemaScope. It required all theaters to install larger screens, purchase special projection lenses, and add an upper stereophonic soundhead on the projectors. *The Robe* was the first picture released in this process. Note the touting of "You See it Without Glasses!"

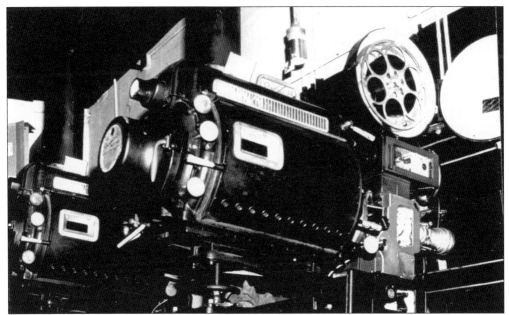

CENTURY THEATRE PROJECTION ROOM, AUDUBON, 1953. The projection room of the Century Theatre was equipped with Simplex "Super" 35-millimeter projectors. This photograph shows them with RCA four-channel, stereophonic soundheads, added above the projector head, the CinemaScope (anamorphic) lens installed, and a standard optical soundhead mounted below the projector head. This was considered "state-of-the-art" for "Scope" projection.

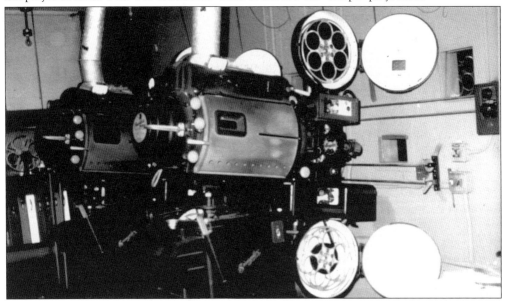

WESTMONT THEATRE PROJECTION ROOM, HADDON TOWNSHIP, 1958. The Westmont Theatre's projection room was equipped with Simplex "E-7" 35-millimeter projectors. As in the Century's booth above, the Westmont installed stereophonic sound for CinemaScope in the mid-1950s. The Westmont Theatre was never equipped for 3-D projection; thus, the machines have standard 2,000-foot magazines installed. Both theaters used Peerless carbon arc lamps on their projectors.

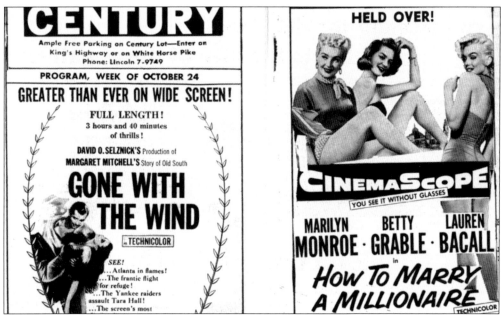

CENTURY THEATRE PROGRAM, AUDUBON, 1953. Now that every theater had a new wide screen, everything had to be seen that way. This program is announcing the presentation of *Gone with the Wind*, as never seen before, and the second picture to be released in CinemaScope, *How to Marry a Millionaire*. Note that the type size for the CinemaScope process is as large as the title of the film.

CENTURY THEATRE PROGRAM, AUDUBON, 1954. A year later, another new film process appears. This one, VistaVision, was from Paramount Pictures and utilized a double width negative that would produce a sharper standard 35-millimeter frame. It is interesting to note that the film processes were considered as important as the title of the picture in the advertising.

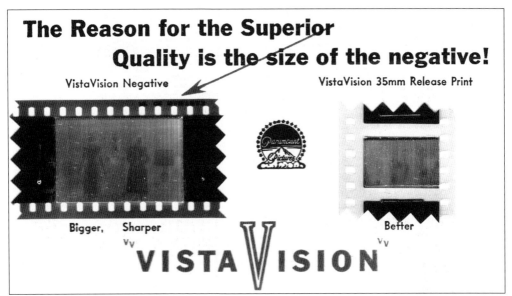

VISTAVISION FILM SAMPLES, PARAMOUNT, 1954. This card was circulated by Paramount Pictures to explain the VistaVision film process. Using standard 35-millimeter film, the film passes through the special VistaVision camera horizontally, creating a double frame, eight– sprocket hole image. It is then reduced to 35 millimeter to make theater release prints that are sharper and able to be projected larger than standard photography.

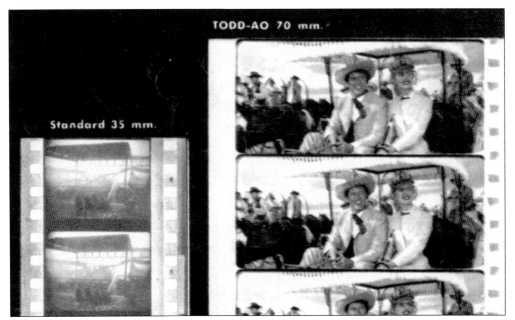

TODD-AO 70-MILLIMETER FILM COMPARED TO 35 MILLIMETER, 1955. Larger screens required more light from the projectors, as well as a sharper image to fill them. Filmmakers looked back to the 65-millimeter width film used for specials like *The Big Trail* in the 1930s. Michael Todd and American Optical developed a 70-millimeter process named Todd-AO that added six-channel sound on the film. They released *Oklahoma!* in this process in 1955. Following initial engagements in 70 millimeter, pictures were reduced and released to theaters in 35-millimeter scope.

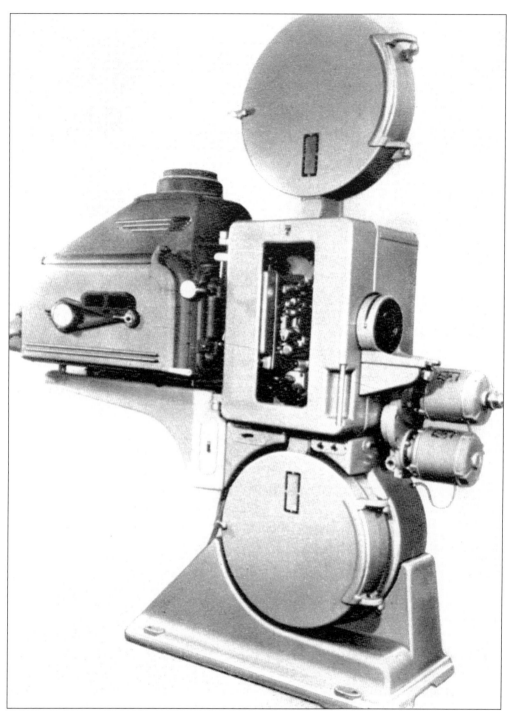

PHILIPS-NORELCO 35-MILLIMETER AND 70-MILLIMETER PROJECTOR, 1955. Philips was the first company to manufacture new projectors to accommodate both 35-millimeter and 70-millimeter film. Simplex, Century, and others soon followed. The projector pictured here could handle all of the new sound and picture processes. South Jersey's first installation of these machines was at the Fox Theatre in Levittown (now Willingboro).

ERIC THEATRE, PENNSAUKEN, 1989. The Eric Theatre in Pennsauken, located at Haddonfield Road and Route 73, was built in 1966 by the SamEric Corporation. It was the first theater in the Camden area to be equipped with the Philips 35/70-millimeter projectors. This photograph shows the theater as it looked for the opening of *Batman* in 1989. The theater was closed in 2004 and razed in 2005. (Courtesy Burlington County Times.)

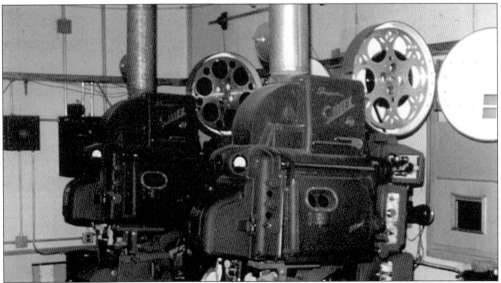

PLAZA THEATRE PROJECTION ROOM, MOORESTOWN, 1963. Opened by the Savar Corporation in 1962, the Plaza Theatre was part of the Moorestown Mall at Route 38 and Lenola Road. This photograph shows the two Century 35/70-millimeter projection machines installed at opening. The projection room also had a third standard 35-millimeter projector for projection of 35-millimeter subjects while presenting a 70-millimeter feature attraction. The Plaza has been multiplexed and is still operating.

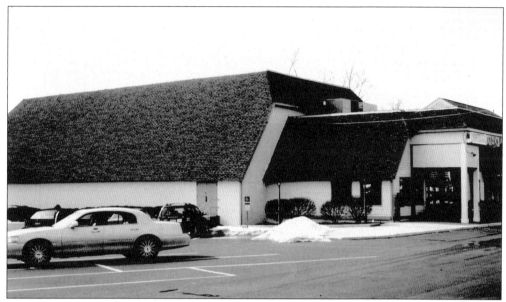

COMMUNITY THEATRE, CHERRY HILL, 1963. Technology was not the only driving force in the movie industry at this time. As the population moved to the suburbs, theaters followed. Robert Scarborough, a developer who built the Barclay Farms residential section of Cherry Hill, designed and built this theater for the Walter Reade Corporation. Originally planned as a showcase for Reade-Sterling foreign and art films, local tastes dictated a change to mainstream entertainment.

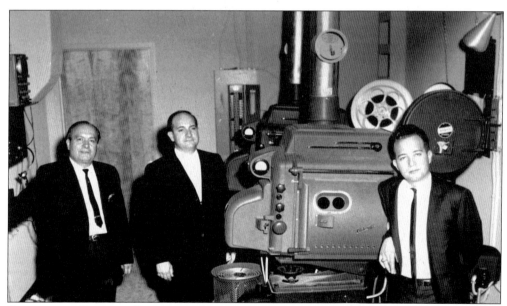

COMMUNITY THEATRE PROJECTION ROOM, CHERRY HILL, 1963. Built primarily for foreign and art films, the projection room was equipped for standard 35-millimeter film, single-channel optical sound, and scope projection. Standing from left to right are Frank Hauss (projectionist), Benjamin Casamassa (manager), and Allen Hauss (projectionist). Soon after changing to a mainstream picture policy, the theater was sold to a partnership of General Cinema Corporation and the Savar Corporation. It is now used for retail space.

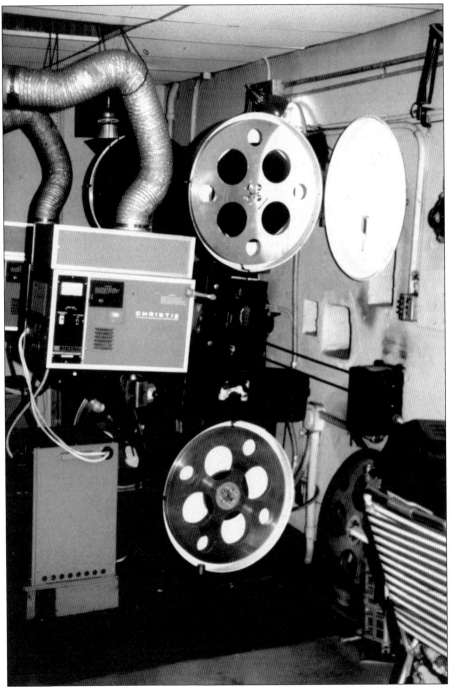

HARWAN BOOTH, MOUNT EPHRIAM, 1970. The late 1960s and 1970s brought more changes to projection technology. Owners of multiple auditorium theaters wanted one projectionist to handle many screens. Initially this was done by using larger 6,000-foot reels allowing an increase from 20 minutes to an hour before necessary changeovers between projectors. To increase the running time of the carbon arc lamps, Xenon bulbs replaced the older carbon arcs. Both the larger reels and Xenon lamps are pictured in this photograph.

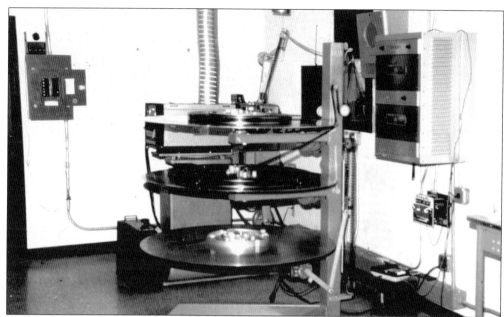

"PLATTER" FILM DELIVERY SYSTEM, ELLISBURG TWIN, CHERRY HILL, 1980. Various methods of automating the change between projectors were tried, but by 1980, the invention of the "platter" eliminated the need for two projectors and changeovers. Up to three hours of film could be loaded onto a platter, the film then pulled from the center and over rollers to feed the projector. As the film left the projector, it was collected, starting at the center, on an empty platter.

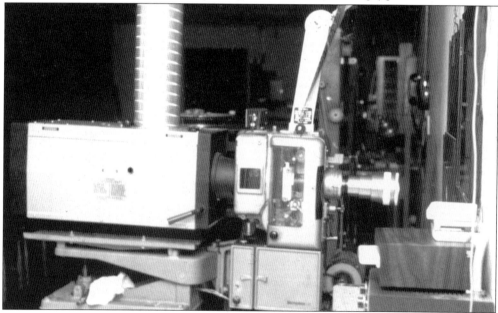

PROJECTION ROOM, ELLISBURG TWIN, CHERRY HILL, 1980. Built as a single-screen theater in the early 1970s, the Ellisburg theater was twinned with a wall up the middle and by using one of its original two projectors, each with a platter system, for each screen. No rewinding is required, simply pull the film from the center of the full platter, rethread the projector, and feed the film to an empty platter. Today most multiscreen theaters operate using this technique.

IMAX Projector, Discovery Museum, Philadelphia, 1976. This was the first installation of the IMAX system in the Delaware Valley. Using 70-millimeter film with an image 15 sprocket holes wide, a very sharp image is projected on a screen several stories high. The film runs horizontally through the projector, similar to 35-millimeter VistaVision. The only motion picture theater in Atlantic City today is an IMAX theater, also equipped for 3-D. Pictured here is projectionist Anthony Falcone (left) and David Hauss.

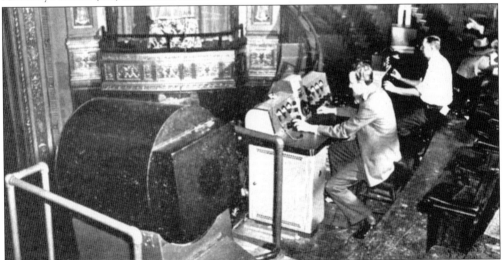

Theater Television Projection, 1941. Since the invention of television, both Hollywood and theater owners have dreamed of "beaming in" the picture from a central source. This eliminates the cost of making and shipping prints, while providing a "scratch-free" image over an entire engagement. In 1941, RCA demonstrated television projection in New York City, followed by installations elsewhere. In the 1950s, the Stanley Theatre, in Camden, had an RCA system installed for special "live" events, the first in South Jersey.

CHRISTIE CP2000 DIGITAL PROJECTOR, 2005. Black-and-white, cathode tube–based analog television could never deliver the quality of motion picture film. However, using high-resolution digital video, Texas Instrument's DLP chips, and Xenon lamps, it is now approaching that quality. Today theater owners are again facing competition from home entertainment; this time it is wide-screen high-definition displays, DVDs, and surround sound. As of 2005, digital, large-screen 3-D projection is being used to show *Chicken Little*, in special limited engagements, providing an experience that cannot be duplicated in the home. While 35-millimeter film has been the entertainment industry's standard for over 100 years, it appears that new technologies will certainly replace it in the not too distant future. (Courtesy Christie Digital Systems Incorporated.)

Six

CURTAIN CLOSED

Most of the theaters pictured in this book brought down their final curtain long ago, and they are for the most part just memories. The few buildings that remain have been converted to other uses. Most people who pass them by or use them are probably not aware that they were once places of great entertainment known as motion picture theaters. Some of these are pictured on the following pages.

It is fortunate that some local officials and town planners are beginning to realize what a theater can actually mean to the vibrancy of a local main street, especially when coupled with shops and gourmet restaurants. Throughout the region, many are attempting to recapture that downtown magic by restoring their theaters, large and small.

In South Jersey, in 2005, only the Broadway in Pitman continues to run stage and film attractions on a regular basis. The stage lights are back on in the Grand in Williamstown, joining the Gateway in Somers Point and the Ritz in Oaklyn, and as of 2005, plans were underway to relight the Levoy in Millville and the Landis in Vineland.

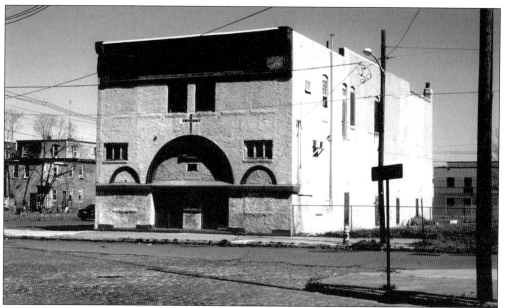

NORTH CAMDEN THEATRE, CAMDEN, 2005. The building that housed the North Camden Theatre at Second and Main Streets is standing and, since closing, has been in continual use as a community church. It is pictured on page 11 as a theater.

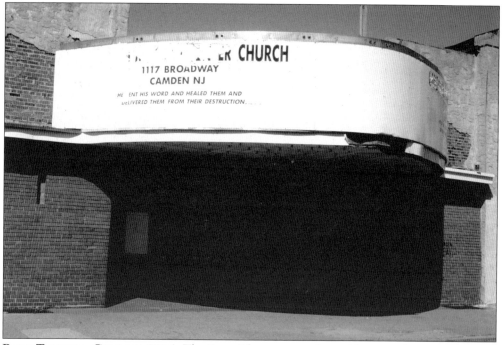

ROXY THEATRE, CAMDEN, 2005. The Roxy Theatre, complete with original marquee, is used as a church. It is pictured as a theater on page 16.

PRINCESS THEATRE, CAMDEN, 2005. This photograph shows the Princess Theatre, at 1108 Broadway, as a used furniture store. The sign covers its marquee. The Princess, as a theater, is pictured on page 17.

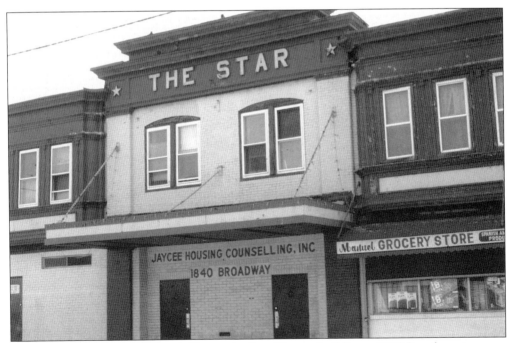

STAR THEATRE, CAMDEN, 2005. Here is the Star Theatre building at 1840 Broadway, in use as a counseling agency. It has also served as an athletic club. Above the second-story windows, the original theater name is still in place. It is pictured in 1945 on page 20.

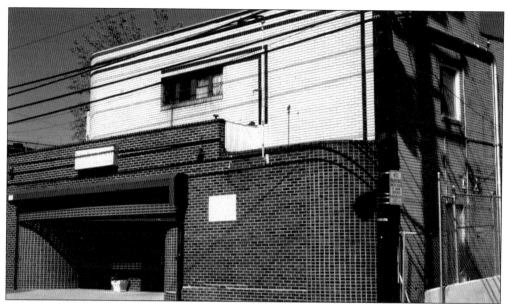

Rio Theatre, Camden, 2005. The art deco Rio Theatre building is still standing at 2711 River Road in the Cramer Hill section of the city. While it is in use as a church, the building retains much of its original look. On page 21, it is pictured in 1939.

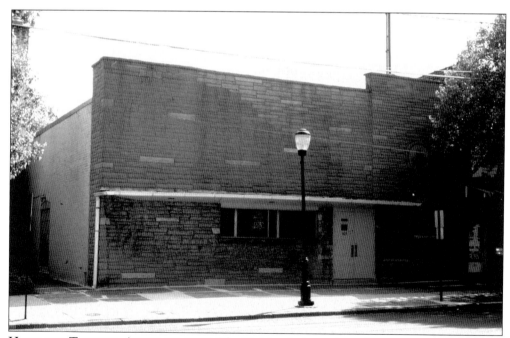

Highland Theatre, Audubon, 2005. The Highland, pictured as a theater on page 22, is shown here in 2005. The building, on Atlantic Avenue, was remodeled for use as a Masonic hall.

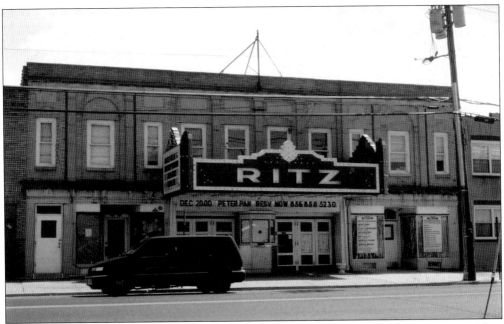

RITZ THEATRE, OAKLYN, 2004. The Ritz Theatre, pictured as a movie house on page 25, is shown here as the home of Puttin' on the Ritz, a live repertory theater venue. The Ritz is one of the very few original buildings still operating as a theater. While the vertical Ritz sign is gone, one can see the steel support structure still in place.

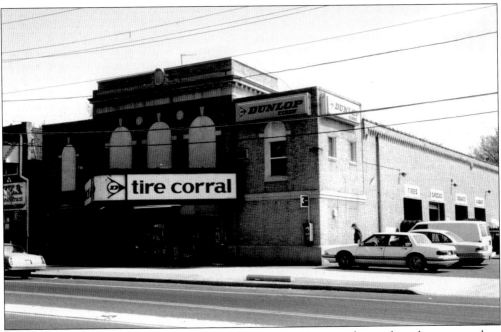

CRESCENT THEATRE, HADDON TOWNSHIP, 2005. The Crescent, featured on the cover and on page 25, is presently in use as an automotive center.

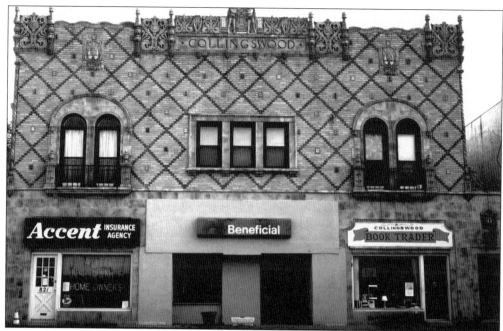

COLLINGSWOOD THEATRE, COLLINGSWOOD, 2004. The Collingswood Theatre's façade is much as it was from the beginning. The auditorium, with fantastic acoustics, has been the site of several Philadelphia Orchestra recordings. The building is used for a variety of office and graphic arts purposes. It is shown as a movie theater on page 28.

LITTLE THEATRE, HADDONFIELD, 2004. Pictured as a theater on page 31, the Little Theatre building has been converted into two very successful retail stores on Kings Highway, Haddonfield's primary shopping area.

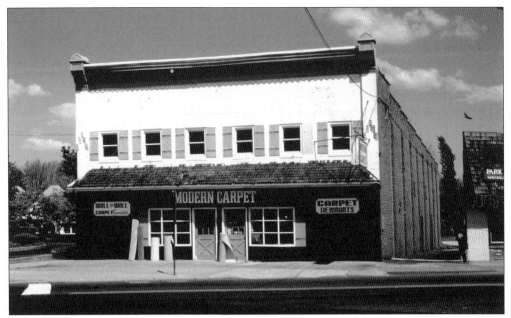

PARK THEATRE, MERCHANTVILLE, 2004. The Park Theatre building is in use as a carpet showroom and warehouse. Much of the original décor remains, including the stage proscenium and the pressed tin ceiling tiles.

PARK THEATRE LOBBY, MERCHANTVILLE, 2004. This is the original lobby area in 2004, now the main carpet showroom. One can see the original theater "half-moon" outside entrance doors installed here to separate the showroom from the warehouse.

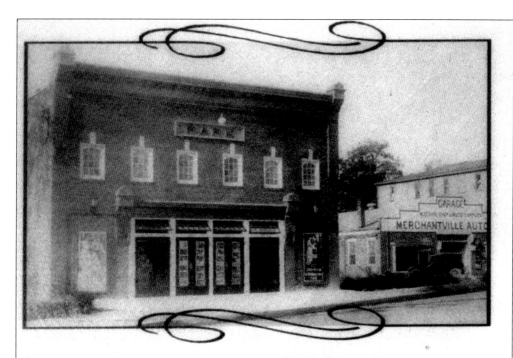

Park Avenue Theatre

The original movie house opened in 1920 housing a large pipe organ and showing fine pictures." Alas, many years have passed since the last film was projected on Merchantville's silver screen. The building has been used as a commercial property since its demise as a movie theatre.

The building next door to the theater was the Merchantville Auto Company and Garage. For many years the Auto Company had a thriving business in the sale and repair of automobiles. This building stood till the middle of this century when it was replaced with the current building.

PARK THEATRE, MERCHANTVILLE, 2004. This is the town's Historical Designation Plaque, located on the right side of the building. It shows the theater's original 1920 façade before the new marquee (page 32) and "half-moon" art deco doors were added in the 1930s.

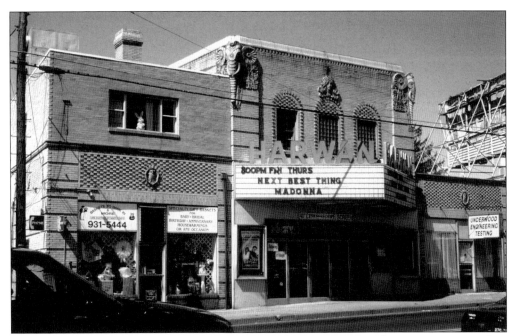

MT. EPHRIAM THEATRE, MOUNT EPHRIAM, 2003. A new marquee and new name appeared on the Mt. Ephriam Theatre in 1970. Taking the name of the owner's family, the Harwan Theatre, while now closed, is scheduled for restoration and reopening in the near future. The theater with its original marquee, around 1939, appears on page 35.

CRITERION/CARLTON THEATRE, MOORESTOWN, 2004. The Criterion Theatre, later named the Carlton, is pictured on page 45. The building still stands in the center of Moorestown's shopping district on Kings Highway and is used for retail space.

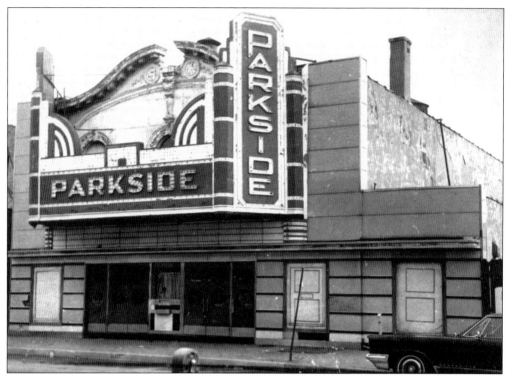

PARKSIDE THEATRE, CAMDEN, 1967. This is a view of the Parkside several years after closing. The building was later purchased for use by a local church group and is still in use today. It can be seen as an operating theater in 1940 on page 20.

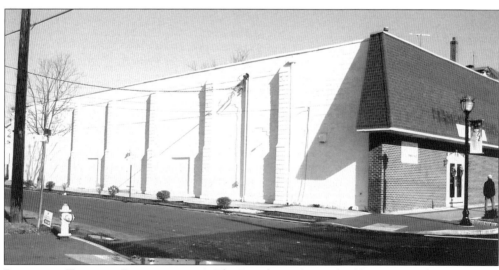

BROADWAY THEATRE, PALMYRA, 2005. The Broadway Theatre building, at Broad and Leconey Avenues, sports a new brick façade and is owned and used by a local church congregation. It is shown in 1941 on page 44, complete with marquee.

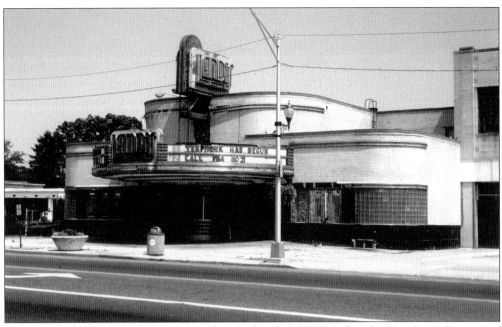

LANDIS THEATRE, VINELAND, 2004. The Landis Theatre, named to the New Jersey Register of Historic Places, has received some matching grants and is awaiting restoration. As can be seen in this photograph, and the 1941 image on page 79, the exterior of this beautiful art deco house looks much as it did when it opened.

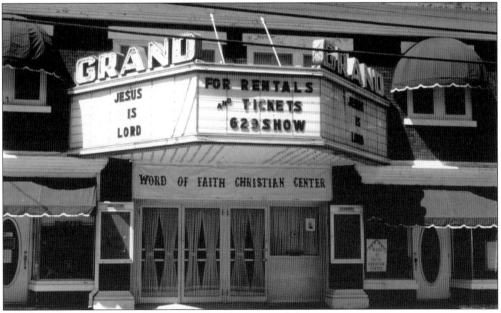

GRAND THEATRE, WILLIAMSTOWN, 2003. The Grand Theatre was used as a church for many years after going "dark." This is how it appeared when purchased by Dale Nelson in 2004. The photograph on page 78 depicts the theater in 1941. The infrastructure has been modernized, the interior restored, and the Grand is operating once again as a live venue, featuring a subscription series planned and performed by the Road Company.

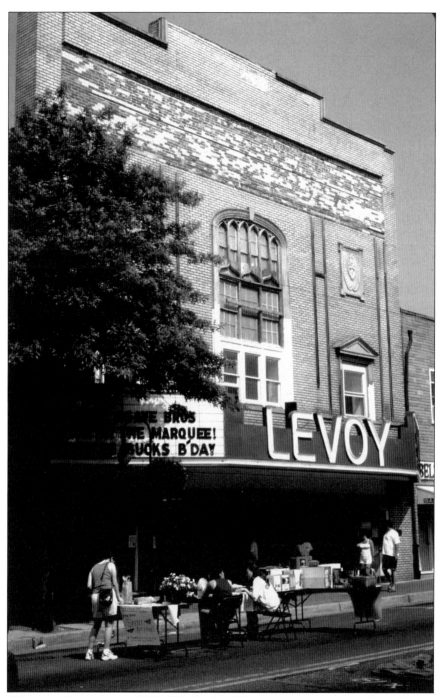

Levoy Theatre, Millville, 2003. The Levoy Theatre is poised to once again become the anchor of Millville's redeveloping High Street. The theater still looks much as it did following its 1927 remodeling, as can be seen when comparing this photograph to the one on page 85. The Levoy Theatre Preservation Society is the sponsor of the annual street fair that is held to raise funds for the restoration. The grand reopening of the Levoy Theatre as an arts venue is much anticipated.

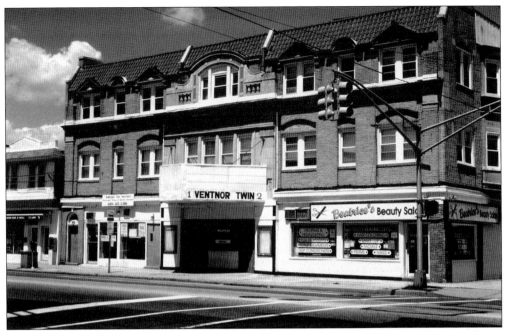

VENTNOR THEATRE, VENTNOR, 2002. This photograph shows the Ventnor Theatre after it was twinned and closed for many years, and just prior to being remodeled and reopened for the 2003 summer season. On page 53, the theater with its original marquee, as it appeared in 1941, can be seen. As of 2005, it is still operating and is the only movie house on the island.

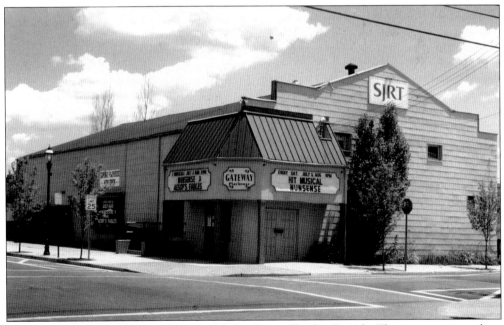

GATEWAY THEATRE, SOMERS POINT, 2003. Originally the Seaside Theatre, as pictured on page 58, it was renamed the Gateway when purchased by the South Jersey Regional Theatre organization. As of 2005, it continues to operate as a live venue, bringing the magic and entertainment of live theater to the area.

MOORLYN THEATRE, OCEAN CITY, 2004. The boardwalk frontage, including the second-floor ballroom, which can be seen on page 56, has been redone as retail stores and condominiums with ocean views. The awning seen on the left side is the new theater entrance. The original auditorium, just past the awning, is now a four-theater complex. The Moorlyn operates as a seasonal house.

BRACA THEATRE, SEA ISLE CITY, 2004. The Braca Theatre Building still stands on what is now JFK Boulevard. It sports a sign that designates it as "the Braca Theatre Building" but is now a combination of retail space and living units. It can be seen as an active movie house in 1941 on page 60.

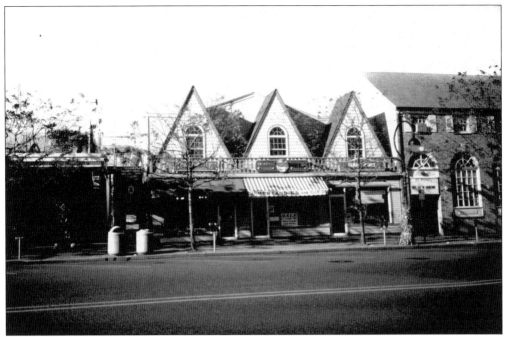

PARK THEATRE, STONE HARBOR, 2003. The Park Theatre building, dating to 1922 and found on Stone Harbor's main shopping street, Ninety-sixth Street, has been converted to several retail stores. It is also pictured on page 61, in operation as a movie house in 1941.

HARBOR THEATRE, STONE HARBOR, 2003. The Harbor Theatre, also on Ninety-sixth Street, opened in 1949, and while operating year-round as a five-screen multiplex, it looks much as it did at its start. The opening night marquee can be seen on page 62.

DRIVE-IN THEATRE ADVERTISEMENT, PENNSAUKEN, 1936. While drive-in theaters are not the subject of this book, two deserve mention because they were unique and were in South Jersey. The Camden Drive-In was the first in the world, developed and patented by Richard M. Hollinshead Jr., a prominent Camden businessman. The theater opened on June 6, 1933. Although it closed within three years, it began a new and major phase of exhibition.

BRIDGETON DRIVE-IN MATCHBOOK, 1960. Pictured are the front and back covers of a matchbook promoting the Original Outdoor-Indoor Drive-In. This drive-in theater was unique in that it also provided indoor, temperature-controlled seating in two 300-seat, glass-front auditoriums that flanked both sides of the concession stand/projection room building. It was the only one of its kind in the Delaware Valley.

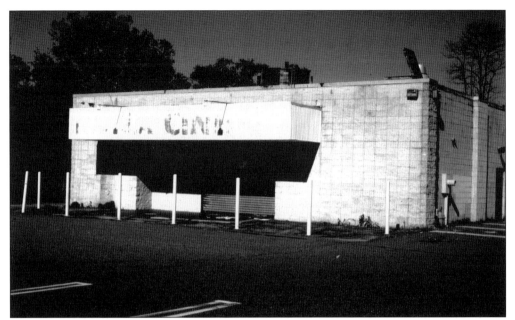

PLAZA CINEMA, TURNERSVILLE, 2003. Located in the Turnersville shopping area, where Routes 168 and 322 meet, the Plaza was but one of many short-lived "mini" theaters that opened in the 1970s and closed in the 1980s. The concept was an automated projection room with 200 to 400 seats, totally operated by a staff of two. As twin and multiplex theaters offered a choice of pictures, these singles screen houses had to make it on the success of one title. Most did not.

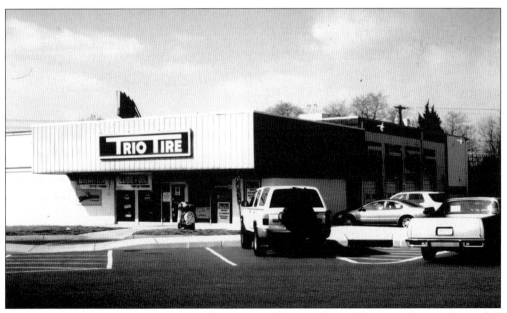

CINEMA 295, CHERRY HILL, 2005. This mini, in the Woodcrest Shopping Center, began life as a Jerry Lewis Cinema franchise along with a second franchise in the Chews Landing area of Gloucester Township. Due to the restriction of showing only G-rated pictures, small audiences forced the closing of both. They later reopened as the Cinema 295 and the Chews Landing Cinema, respectively. Again failing to attract sufficient crowds, both became retail space.

SPRINGDALE THEATRE, CHERRY HILL, 1975. This 125-seat mini was opened by partners Allen Hauss, Joseph Soldo, and Gordon Hamson in April 1975 to provide South Jersey with a showcase for foreign and repertory film. Specialized film programming was very successful in many communities but nonexistent in the Camden area. The theater never developed a large following and closed in 1976. (Courtesy Burlington County Times.)

CINNAMINSON TWIN CINEMAS, 2005. As single-screen theaters were converting to two screens to attract larger audiences by offering a choice of pictures, newer theaters were being built as "twins" to start. This one was in the Cinnaminson Mall on Route 130. The area soon had more screens than the population could support. As attendance fell, many theaters changed to a second-run, low-admission policy, just as home video was taking that same role.

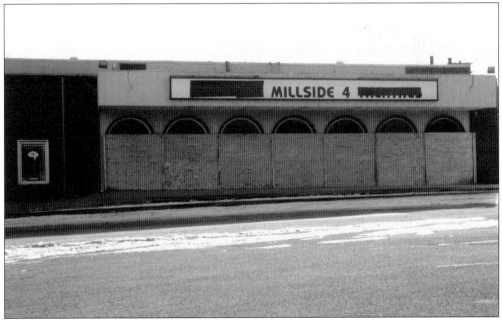

MILLSIDE 4, DELRAN, 2003. Located in the Millside Shopping Center on Route 130, this theater was originally built as a twin in the late 1970s. Due to increasing competition from larger multiplexes, it was converted into a fourplex in the 1980s and finally closed in the 1990s. Like the Cinnaminson above, it is scheduled for demolition.

STANLEY COMPANY ADVERTISEMENTS, ATLANTIC CITY, 1929. This is a paste-up of the Stanley Company of America advertisements for their Atlantic City theaters in 1929. Take special note in the Stanley Theatre display of the "All-Talking! All-Singing! All-Dancing!" description for *Close Harmony*, as well as other promotions for sound throughout this block advertisement.

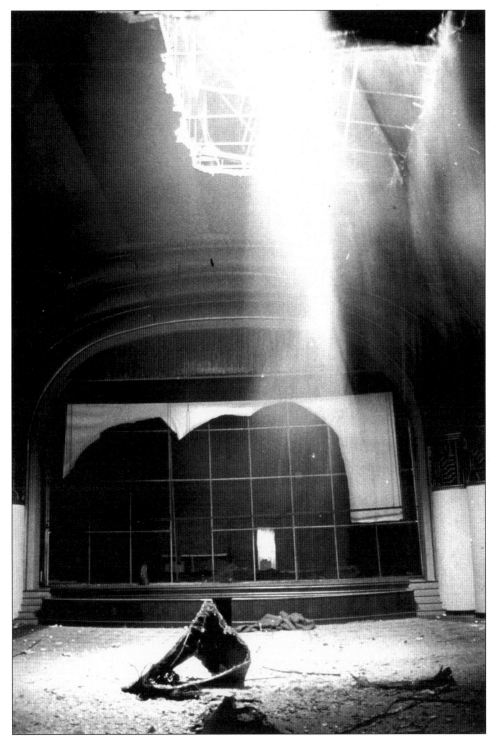

STANLEY THEATRE, CAMDEN, 1966. The sun is peeking through the iron work of the roof, the screen has been torn from its frame, and all seats have been removed as the Stanley Theatre bids farewell to the city of Camden. (Courtesy Robert C. Semler.)

BIBLIOGRAPHY

The Exhibitor 12, no. 10 (December 15, 1928).
The Exhibitor 21, no. 1 (November 15, 1938).
The Exhibitor 34, no. 24 (October 17, 1945).
The Exhibitor 47, no. 20 (March 19, 1952).
http://barton.theatreorgans.com.
http://www.dvrbs.com/CamdenNJ-MovieTheaters.htm.
http://www.moorlyn.com.
http://www.mrboardwalk.net.
Leaf, William. *The History of Runnemede New Jersey 1626-1976*. Borough of Runnemede, 1981.
Maloff, I. G. and W. A. Tolson. "A Resumé of the Technical Aspects of RCA Theatre-Television."
 RCA Review VI, no. 1 (July 1941).
McMahon, William. *South Jersey Towns*. New Brunswick, NJ: Rutgers University Press, 1973.
———. *The Story of Hammonton*. Egg Harbor City, NJ: Laureate Press, Inc., 1966.
Wid's Year Book. 1921–1922. New York: Wid's Films and Film Folks Inc., 1921–1922.
Wid's Year Book. New York: Wid's Films and Film Folks Inc., 1922–1923.